# Art
# Education

# Art Education

a strategy for course design

*Maurice Barrett*

HEINEMANN EDUCATIONAL BOOKS

Heinemann Educational Books
22 Bedford Square, London WC1B 3HH

LONDON EDINBURGH MELBOURNE AUCKLAND
HONG KONG SINGAPORE KUALA LUMPUR NEW DELHI
IBADAN LUSAKA NAIROBI JOHANNESBURG
EXETER (NH) KINGSTON PORT OF SPAIN

ISBN 0 435 75053 4

Set, printed and bound in Great Britain by
Cox and Wyman Ltd,
London, Fakenham and Reading

# Preface

Desmond Hogan said to the Drama Advisers Conference in 1976:

> One of the most interesting intellectual positions in educational theory in recent years has been that associated with the phenomenologists' concept of 'negotiated meaning'. In many senses it represents an important aspect of the ideology of our age – the ideology of confusion, one might say, since it seems most appropriate to a period of declining consensus and increasing contention over 'standards', of rejection of many, if not all, forms of authority, and, in general, the replacement of most 'givens' by problematics . . . a process felt first and most acutely in the Arts. In such a period the concept that no institution has a 'reality' other than that continually created and re-created by the interactions of its members, or, similarly that no form or structure of knowledge can be said to exist or possess validity beyond the meanings negotiated and re-negotiated by real people in their daily transactions, seems a 'natural' development. However, and perhaps paradoxically, this period seems also to have generated a hunger for clarity, for certainty and some stability, and an increasing impatience with much that now seems woolly in traditional educational thought and practice – wooliness which was both acceptable and useful in an earlier period of greater uniformity of ideals.

We have often approached Art Education in the past as though it had a distinct reality and many of us have believed that our understanding of Art Education was universally valid. If Art Education is 'continually created and re-created by the interaction of its members' and the meaning continually negotiated, then we need some framework of considerations, so that all members can be contained and negotiate their meaning one to the other.

Art Education has suffered from the 'messianic arrogance' of

individuals and groups. The time has come for the clarification of essential issues, so that the idiosyncratic and iconoclastic nature can be retained in a form capable of accommodating all aspects. Any framework that destroys the essential nature of the discipline or hinders the negotiation of meaning could become merely an alternative arrogance, but we should try to elucidate the main areas of concern so that the dialogue can commence.

This book is not intended to create a specific syllabus of subjects or activities for art teachers; nor will it attempt to prescribe a particular course of action. The intention is to locate the major areas for decision making and indicate the spectrum of possibilities within this range. This will often be achieved through the discussion of the extremes, but it is hoped and expected that the reader will place his own experience within the framework so that he is able to relate and contribute to the whole.

A syllabus for a course of study, by its very nature, is a formal document of intentions. This does not mean that it will be formal in operation or that it is impossible to create a syllabus of activities which are essentially informal. For this reason, it may be useful to think in terms of the strategies used by teachers to achieve their general aims or specific objectives. The syllabus is, therefore, seen as a set of decisions made about the strategies employed to achieve a general or specific outcome. This short book attempts to create a background against which any individual or group of teachers can sort out the best way *for them* to achieve *their* aims for *their* particular pupils. As the detailed construction of the syllabus will be left to the individual teacher or department, the more general term 'course design' will be used in the book.

# Acknowledgements

It is usual in a publication such as this formally to acknowledge the work of all those who have been associated with its creation and production. Wives, secretaries, printers and helpers of all kinds are listed. It is obvious that I could never have got this work as far as the present reader without considerable help from a wide range of people.

However, in this case, I want to single out a small group of teachers who worked with me continually for about two terms sorting out the problems, solutions, and ideas that eventually formed themselves into this book. Although I myself have finally put the framework together, I could not have done this without the continual probing, stimulating, questioning, enlightening, and informing guidance of these teachers, hot from the classroom. No thanks can truly reflect my gratitude for their time and help. They are

Mike Conroy, Eddie Greenstein, Cliff King, Bob Middleton, Martin Phillipson, Val Porter, Maggie Ridley, Miriam Smith-Phillipson, Phil Tootell, and Joyce Whitehead.

I would also like to thank Pat Morgan and Gwen Curtis for deciphering my script and bringing it to the form in which you are reading it; Sue Martin for keeping me organized and helping with the diagrams; Bob Middleton for reading the original script, and all the other poor devils looking for their names in vain. Thank you all.

M.B.

# Contents

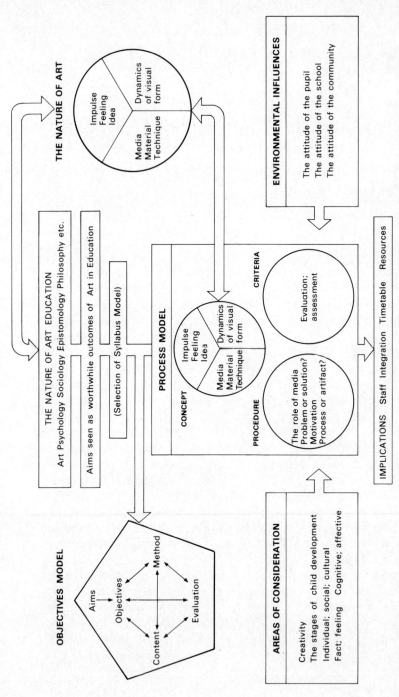

**Fig. 1.1** The structure of the book, showing the relationships of the parts to the whole. (*It will be useful to refer to this diagram as each chapter is read, so that the chapter is understood in relation to the whole framework for course design. This will be essential for the reader referring to a single section of the book.*)

THE NATURE OF ART

Impulse
Feeling
Idea

Dynamics
of visual
form

Media
Material
Technique

THE NATURE OF ART EDUCATION
Art Psychology Sociology Epistemology Philosophy etc.

Aims seen as worthwhile outcomes of Art in Education

(Selection of Syllabus Model)

PROCESS MODEL

CONCEPT

Impulse
Feeling
Idea

Dynamics
of visual
form

Media
Material
Technique

PROCEDURE

The role of media
Problem or solution?
Motivation
Process or artifact?

CRITERIA

Evaluation:
assessment

ENVIRONMENTAL INFLUENCES

The attitude of the pupil
The attitude of the school
The attitude of the community

IMPLICATIONS   Staff   Integration   Timetable   Resources

OBJECTIVES MODEL

Aims

Objectives

Method

Content

Evaluation

AREAS OF CONSIDERATION

Creativity
The stages of child development
Individual; social; cultural
Fact; feeling   Cognitive; affective

# 1 Why make a syllabus?

The last decade has seen a considerable increase in the number of studies and projects across a wide range of the school curriculum. Mathematics, Science, English, and Social Studies teachers have taken strength from the Schools Council, Nuffield, Newsom, and Bullock, so that they are now more able to justify their subject's position in the curriculum and to demand a greater share of time, space, and money. This increased awareness and heightened ability to be articulate about their subjects is one of their strongest weapons in working for curriculum development, whether this be first, second, or third hand in origin.

Against this, art education has been badly served by national institutions and by the unwillingness or inability of art teachers to formulate a case to justify and clarify the important function they are performing in the curriculum. (In fact, a fairly common attitude among art teachers is that if 'they' are too unenlightened to recognize the obvious value of my subject, why should I waste time explaining.) At a time of the greatest need for a balanced curriculum, there is an increased emphasis on formal, cognitive, and impressive forms of education. Art is losing ground because of its apparent inability to articulate its case.

Apart from enabling a case for art education to be made to other members of staff, a course design or syllabus can become the means of giving coherence to the day-to-day intuitive activity which is often the core of the best teaching. A course structure can become the means for the individual art teacher to understand more clearly what he is doing and to create a framework for communicating this to others.

Most of us require some form of structure to give meaning to the chaos of living. Behaviour, to be intelligent, must be organized and adaptive to facts and experiences; that is, adaptive to a world that exists out there, and overcomes egocentricity. Most art teachers would fight tenaciously to retain the freedom to decide upon the form and method of their teaching. If one of their aims is to create divergent, open-minded, tolerant individuals capable of behaving idiosyncratically, they will also require that the teacher should be free to act in the same way. If all art activity assumes iconoclastic behaviour (i.e. challenges cherished beliefs and forms), the teacher must be sufficiently free and flexible to create criteria appropriate to the activity of each child, no matter how individual or social is the response and behaviour.

The art teachers' reluctance to define strategies and rationales for their subject arises from a fear of being confined in a structure which will restrict their freedom, flexibility, idiosyncrasy, and iconography. By creating an open frame of reference for all major areas of consideration in art education it is hoped to enable any teacher to locate himself in this structure, which is also capable of accommodating others of totally different persuasion.

I should be able to locate myself as an art teacher in this frame of reference and allow for Ken Baynes, Victor Pasmore, Henry Pluckrose, Sybil Marshall, Seonaid Robertson, Kurt Rowlands, *et al.* also to locate themselves in the frame, and consequently relate themselves to me. In this way, the dialogue within art education could open up and flow more easily. The need for this was clearly stated by Ronald MacGregor:

> Since it is improbable that art teachers could ever be processed to fit a curriculum, the alternative is to build sufficient flexibility into the design of the curriculum to permit the teacher an individual and personal interpretation of its contents. This is hardly a novel idea, yet the format of many curriculum guides would seem to afford proof that it has not often been translated into practice.
>
> (MacGregor, 1970)

It must be emphasized that this framework does not seek to prescribe the way the teacher operates, but allows him to operate within a total framework in a way most natural to him.

We must first create a means of understanding ourselves within

the chaos of art education at present. There is no immediate inten-
tion to reform the teacher, the system, or the school. The initial
objective is to clarify, and from the more informed and enlightened
debate which will follow perhaps we shall be able to improve each
teacher's contribution to art education.

# 2 What is the nature of art?

Any definition of art is, by the very nature of the subject, incomplete and open to dispute. Definitions are usually made to fit the hypothesis which follows. I do not intend to be an exception. My definition fits my hypothesis, but I hope that it is general enough to be acceptable to most readers. Herbert Read says:

> That it (art) has been so elusive is explained by the fact that it has always been treated as a metaphysical concept, whereas it is fundamentally an organic and measureable phenomenon. Like breathing it has rhythmic elements; like speech expressive elements; but 'like' does not in this case express an analogy; art is deeply involved in the actual process of perception, thought and bodily action. It is not so much a governing principle to be applied to life as a governing mechanism which can be ignored at our peril.
>
> (Read, 1944)

He later lists the main principles involved in art; *the principle of form*, and the *principle of origination*. Form is a function of perception, and origination is a function of imagination. He also draws attention to the biological and social aspects of art.

I see art as a process rather than an artifact. It is something which can be recognized only in its entirety or unity, but which can be defined only by describing its main facets. The three facets I wish to identify are dealt with as if they were separate entities, but art is not possible, in my opinion, unless the elements are reflexive, i.e. the parts are inter-related so that each responds to change in the others. (See Fig. 2.1, and Witkin (1974).)

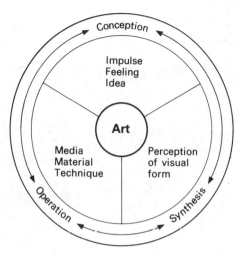

**Fig. 2.1** The nature of art.

## 1 THE CONCEPTUAL ELEMENT

*Idea, impulse, feeling* This is the aspect of art which is concerned with personal reality, concept formation, response to sensation and experience, and the realization of phenomena, symbols, myths, and fantasies. It operates through sensation, emotion, reminiscence, association, and inference.

## 2 THE OPERATIONAL ELEMENT

*Media, material, technique* This is the aspect of art concerned with the physical nature of the world and the ways of using it as a means of developing and understanding it. It is through the manipulation of the environment that we are able to control it for our personal or social ends. The materials are everything that we use. They become the media through which we express and communicate our ideas, impulses, feelings. The effective use of these materials is achieved through the development of the appropriate techniques and skills so that our results match our concepts.

## 3 THE SYNTHETIC ELEMENT

*The dynamics of visual form* This aspect is concerned with the struc-ture of visual form which is used to convey the concept through the

materials. Perception is the basis for this element and involves the unified apprehension of the external world. The form of art is the shape that it takes.

Art is the use of media to organize our subjective experiences in visual form.

# 3 What is the nature of art education?

On the basis of my contact with a large number of art teachers, I am assuming that there is general agreement about the aims of art education (see pages 13–20). It is in the formulation of procedures to achieve these aims that the problems arise. I can do no better than to return to Herbert Read for a statement of principles with which, I believe, a majority of art teachers would identify.

> Such aesthetic education will have for its scope:
> (i) the preservation of the natural intensity of all modes of perception and sensation;
> (ii) the co-ordination of the various modes of perception and sensation with one another and in relation to the environment;
> (iii) the expression of feeling in communicable form;
> (iv) the expression in communicable form of modes of mental experience which would otherwise remain partially or wholly unconscious;
> (v) the expression of thought in required form.
>
> (Read, 1944, p. 8)

Most writers on art education see the role of art as a means *through* which we educate. Whilst many art teachers hold this to be true, there are some who operate as though art were an end in itself.

> The purpose of education can then only be to develop, at the same time as the uniqueness, the social consciousness or reciprocity of the individual. As a result of the infinite permutations of heredity, the individual will inevitably be unique, and this uniqueness, because it is something not possessed by anyone else, will be of value to the community. It may be only a unique way of speaking or of smiling – but that contributes to life's variety. But it may be a unique way of seeing, of thinking, of expressing

mind or emotion – and in that case, one man's individuality may be of incalculable benefit to the whole of humanity. But uniqueness has no practical value in isolation. One of the most certain lessons of modern psychology and of recent historial experience, is that education must be a process, not only of individuation, but also of integration, which is the reconciliation of individual uniqueness with social unity. From this point of view, the individual will be 'good' to the degree that his individuality is realised within the organic wholeness of the community. His touch of colour contributes, however imperceptibly, to the beauty of the land-scape – his note is a necessary, though unnoticed, element in the univer-sal harmony.

(Read, 1944, p. 5)

More specifically, Read talks about the arts as much as art as a means of educating. He continually emphasizes 'the importance' of the subject to education and the incompleteness of education with-out it.

It must be understood from the beginning that what I have in mind is not merely 'art education' as such, which should more properly be called visual or plastic education: the theory to be put forward embraces all modes of self-expression, literary and poetic (verbal) no less than musical or aural, and forms an integral approach to reality which should be called aesthetic education – the education of those senses upon which con-sciousness, and ultimately the intelligence and judgement of the human individual, are based. It is only insofar as these senses are brought into harmonious and habitual relationship with the external world that an integrated personality is built up. Without such integration we get, not only the psychologically unbalanced types familiar to the psychiatrist, but what is even more disastrous from the point of view of the general good, those arbitrary systems of thought, dogmatic or rationalistic in origin, which seek in despite of the natural facts to impose a logical or intellectual pattern on the world of organic life.

(Read, 1944, p. 7)

It is the development of each individual's reality within his natural and social environment that seems common and fundamental to all art teaching. This implies an active extension of reality rather than passive viewing. This, in turn, demands of the art teacher a pro-cedure which will in some way encourage the individual to accept the challenge, and develop the means of responding to it in some positive way.

If these principles appear to be so general that they are meaning-less, it is because in the past when we have specified our aims,

distinct procedures have been formulated which have polarized into rival factions and the essential unit of purpose has been lost. It is only in the most general statement of principles that there has been agreement.

The main aim of a course design should be to maintain the areas of agreement, whilst allowing for each teacher to make a unique approach to art education and work reflexively with others. This can be achieved only if there is a mutual understanding of the form of contribution which each is able to make. If this happens, the different approaches can support one another in achieving their common aim. All courses should be designed to take account of the idiosyncratic nature of art and artists. In no way should this be seen as a compromise. Without this divergency of approach an essential element of art education would be lost. If art is idiosyncratic, divergent and unique, then the process of art education must contain the possibilities for all of these. Any course which prescribes a particular approach to the exclusion of all others will only serve those who can work within the set boundaries. The rest will be excluded.

# 4 The aims of art seen as worthwhile outcomes

### 'Worthwhile to whom?'

The answer to this question is open to debate, but it may be useful to attempt to create a framework within which each teacher will be able to locate a possible answer. Outcomes can only be seen as worthwhile within the context of the pupil and the society within which he lives.

> ... it seems valid to assume that boys and girls are maturing, in a social sense, earlier than they used to. Manifestations of this occur in students' desires to be delegated a greater amount of responsibility in the shaping of society, and to be permitted to discuss, critically and evaluatively, that society to which they presently belong. While these phrases have an old familiar ring to them, few current art curriculum guides offer specific opportunities to discuss one's environment in such a way that the child develops a discriminating eye and, at the same time, a vocabulary which he can use to make his thoughts explicit.
>
> (MacGregor, 1970)

MacGregor brings out several points here that are worth elaborating. There is a great deal of criticism of both schools and pupils at present, particularly with regard to the education of the 'responsible citizen'. Paradoxically, most of this comes from people demanding 'more' and 'better' of what we have, i.e. a didactic approach which attempts to transmit to the pupil the form of responsibility required. A pupil will only grow into the 'responsibilities' of adulthood if he is given the opportunity to develop the elements which constitute this quality. 'Responsibility' has to operate within a society comprised of disparate norms. A responsible adult understands the range of

options open to him through experiencing the effect of these 'norms' upon himself and he gradually determines which of the 'norms' seem appropriate to his own reality (accepting that this reality is already 'norm' influenced or moulded). He must then have some opportunity to experience the effects of a variety of possible decisions. School must create this opportunity whilst minimizing the effects of 'wrong' or inappropriate decisions. The pupil must learn through making personal choices, but, of course, without destroying his 'self', or the system.

With a didactic approach the pupil is shaped into society, and the 'self' is neglected. Society thereby suffers from the way in which all its elements conform to the system. School must engender self-awareness so that society can become enriched by the existence of many individuals.

The 'self' needs a means of making ideas and thoughts explicit so that there is a basis for negotiation between self and society. This means of communication must go beyond mere verbal language. Art is a vital means of self-realization within the framework of education for it assumes that personal experience can be generally transmitted and utilized.

The pupil needs to discover himself, but he also needs to find out how his main interests, obsessions, needs, and abilities relate to others and society in general. This understanding must come through experience, and it is one of the main functions of art education to provide opportunities for the pupil to achieve this. The conceptualist will not operate at his best in a 'design' framework, but he should be able to understand how his abilities relate to those of others. This will sponsor tolerance of others and confidence in self. Society will be understood as a complexity of parts. Of course, in the early stages of education the pupil will have to be led into simple areas of decision-making, so that a basic understanding is attained before complexities are attempted.

The world is not only composed of relationships, it also has an objective reality from which individual and social reality is created. The pupil should be given every opportunity to confront the natural and man-made environment. He should be encouraged to approach it creatively as something capable of stimulating feeling, impulse, and ideas and to respond to it through medium and form. It is this process of discovery and realization which is at the base of art in education *for the child's benefit*. The manipulation of any materials

can give rise to impulses and feelings which will foster design aptitudes, art and craft abilities, greater visual and tactile perception, and an awareness of countless possibilities. Art attempts to provide full scope for diverse response by not prescribing specific objectives. The diversity of the pupils should be matched by the flexibility of the teachers. Although there are certain behavioural objectives which are inevitably defined in advance (as in the development of craft skills and the ability to manipulate materials), in most cases specific objectives should be set aside and the activity should be evaluated *post facto* in terms of its *results* and how these benefit self or society.

Many subjects could have as their objectives the realization of the self within the community. The special value of art education lies in its particular concepts, procedures, and criteria. The pupil should be able to develop visual perception in tactile and spatial terms. This perception must be seen as his own whilst nevertheless related to that of others. Personal perception based upon direct sensory experience should be the foundation of all art education. Through continual response to sensory experiences the pupil must become increasingly aware that relationships, differences, similarities, order and chaos are part of the world. He should be able to respond with increasing thoughtfulness to his perceptions and as he becomes more sensitive he also becomes more discriminating in his own activity and in his response to the work of others. Each aspect of art education sharpens certain faculties, and these in turn sharpen others. Equally, any false 'sensitivity' created by stylized responses or cultural brainwashing will inevitably dull the senses and sensibility. One of the many factors blunting the child's sensitivity within society at the moment is the 'norm-based' form of our education system. Personal sensitivity is often seen as idiosyncratic and a dangerous challenge to the stable, conforming nature of society.

## Defining some worthwhile outcomes of art and craft

Most teachers will be able to identify what they see as the worthwhile outcomes of art without defining them in terms of measurable behavioural changes, or finite achievements. Before elaborating a Process Model for an art course it may be useful to list some of the most commonly stated aims and exemplify them in operational terms. It must be emphasized that most of these outcomes could not

be achieved if the pupils were limited by prescribed activities. The emphasis is on individual perception of reality and creativity, and art as a thinking system concerned with qualitative judgement. As Lawrence Stenhouse says, 'We must be careful that we do not allow the use of methods of distort content in order to meet objectives.' (Stenhouse, 1970)

Most art teachers are capable of stating aims for their subject but there is often a considerable difference between their written syllabus and their operations within the classroom. This is not to say that their practical work is without aims at all but that it is often successful in achieving aims quite distinct from those originally stated. This section attempts to relate aims to outcomes by exemplification.

Some of the outcomes listed below are the same ideas stated in different terms. There is no intention to set a rigid list of outcomes or exemplifications. The following are examples of worthwhile outcomes suggested and discussed by one group of teachers. It is assumed that most teachers would identify others, state them differently and exemplify them by alternative methods.

### SOME WORTHWHILE OUTCOMES AND EXEMPLARS

**1** To develop the ability to perceive the world in visual, tactile, and spacial terms.
*Exemplar:* The pupil should be able to indicate through the creation of visual images that his own perception of 'objective reality' is derived from his sensory experience of it. In this way a drawing of a landscape should tell us how the pupil perceives the landscape and responds to it, rather than communicate a norm of 'objective reality'. Landscape painting is a frame of mind, not a statement of fact. The 'frame' is determined by the individual's perception based upon response to the sensory experience.

**2** To develop sensitivity in response to changing perception.
*Exemplar:* The pupil should be aware of subtleties and variations within his perception of the world. He should be able to demonstrate this awareness through his manipulation of materials. He should be able to demonstrate his awareness of the subtle change in the colour of an object throughout a day, *or* interpret these changes in terms of mood *or* indicate how the change of colour suggests a change of form.

**3** To be able to recognize the nature and form of problems inherent in self, society and the environment, with particular reference to visual and tactile experience.

*Exemplar:* When presented with a piece of clay *or* a series of photographs *or* an arrangement of coloured shapes *or* a series of statements, the pupil should understand that, in manipulating them, certain conflicts and problems become apparent which may be solved or responded to in visual and tactile terms.

**4** To be able to work flexibly within an infinite range of possible solutions.

*Exemplar:* When presented with problems associated with the simple materials of traditional crafts, the pupil should not move directly towards a prescribed solution. When presented with clay he should not automatically begin to make pots or figurines, but should spend time finding out how many holes can be made in the clay before it collapses, *or* which are the best ways of manipulating clay in its different states (slurry to baked). The objective is to avoid suggesting traditional craftwork and to exploit the potentialities which the pupil discovers in the material for his own ends, or for some other purpose which he selects.

**5** To be able to discriminate between the various solutions to a problem, and to choose the most appropriate to self, society, and the environment.

*Exemplar:* The pupil should learn to test the appropriateness of a design solution on the basis of his experience and understanding of the elements used and the operational constraints. For example, in designing a chair, the requirements of a particular individual may not fit the socially defined function of a 'dining chair', 'armchair' or 'shooting stick'. In solving such problems the realm of constraints and potentialities must be understood.

**6** To be able to realize personal uniqueness in a community or in society as a whole, so that the pupil can learn from and contribute to society.

*Exemplar:* The pupil should be able to see that in attempting to solve the problem, 'make the highest, free standing structure out of a newspaper', each individual could present a unique and valid solution assessed in terms of self and society.

**7** To develop a wide range of expression and communication skills, based upon visual and tactile experience.

*Exemplar:* The pupil should be able to express and communicate

ideas through a variety of media, e.g. painting, photography, col-
lage, wood, clay, metal, so that ideas which are conceived by him in
non-verbal form have a means of being expressed in the form of
their conception, or some appropriate alternative. Visual experi-
ences and ideas should be expressed visually and not necessarily
interpreted through language. The pupil can say more about his
perception of the space around him in visual terms than he can in
words because he understands space through vision and move-
ment. He is more able to communicate his understanding of an
experience if he chooses the form closest to it.

**8** To be able to see that all man-made objects are the result of his
manipulation and organization of the physical environment.
*Exemplar:* The pupil should be able to see that a house is not only a
social or architectural concept – it is also the result of the manipula-
tion of materials to achieve a particular community function. A
sculpture is a similar process but towards a different end. When
given a material he should be able to use its possibilities to achieve
the particular end he requires.

**9** To develop self-reliance by experience in problem-solving and
decision-making.
*Exemplar:* The pupil should be sufficiently visually aware to be able
to recognize and define his own problems and solve them. This
requires his awareness to be self-motivated and strong enough to
support activities associated with the solutions to problems. Passive
awareness is not enough. In the third, fourth, and fifth forms, the
pupil should not only be able to define the initial area of interest and
enquiry but should also be able to develop ideas out of his subse-
quent activities and deliberations.

**10** To be aware of the quality and effects of ideas and decisions
stemming from others.
*Exemplar:* When confronted with something like a 'polystyrene
pellet-filled cushion chair' the pupil should be able to evaluate its
appropriateness as an object and the ingenuity of its construction.

**11** To understand the expression of personal feelings and
impulses to such an extent that sense can be made of a world shared
with others.
*Exemplar:* None necessary, I hope.

**12** Art should be recognized as a form of thinking able to sustain
creative ideas and provide a framework for judgement.
*Exemplar:* There are many forms of expression in advertising and

television which are purely visual. The pupil should come to understand that many of these visual ideas are incapable of being expressed adequately in any other form.

**13** To develop the ability to modify what is seen so that a personal response to it can be demonstrated.
*Exemplar:* Best exemplified in terms of Picasso's 'Ape out of model car' and 'Bull out of bicycle saddle and handlebars', Dali's 'Mona Lisa with moustache', Graham Sutherland's portraits and Van Gogh's 'Sunflowers' and 'Chair'.

**14** To develop the ability to organize marks, shapes, and forms so that they communicate or demonstrate our response to what has been observed.
*Exemplar:* The pupil should be able to put down in a visual form information about things he has seen. He should be able to communicate the structure, form, shape, texture, colour, and so on of a flower or corn-cob, not necessarily in a traditional drawing form but as a collection of information put down in the most simple, direct way. The pupil could be asked what forms are used to give information about a house. There are many different drawing forms used to communicate a wide range of information. The pupil should be able to select the most appropriate form for the information he wishes to communicate.

**15** To recognize that the content of any work of art is expressed through the personal manipulation of form.
*Exemplar:* Pupils given a group of objects (e.g. a ball of clay, a box of wooden cubes, or a collection of coloured discs) and allowed to manipulate them freely will each develop a different form. These forms will vary in expressive and aesthetic quality, but the differences will derive from the way in which each individual has manipulated them.

**16** To externalize our personal reality through the manipulation of visual form.
*Exemplar:* A group of pupils is each given an identical black and white photograph of a landscape. Each member is asked to change its expressive quality,

(a) by selecting part of it in order to change the nature of its expressive composition,
(b) by introducing colour to change its mood,
(c) by changing its tonal relationships to introduce some dramatic quality.

When viewing the final result the pupils should be aware that, although each member has used and retained the original material, the changes in the formal elements of design have created different expressive images.

**17** To understand the dynamics of visual form.

*Exemplar:* Pupils should be able to design images through an understanding of the weight, direction, and balance which are created by the use of different forms. In reorganizing these they can change the dynamic effect, e.g. the use of colour tones to give visual weight to a design; the use of line to give direction.

**18** To develop the ability to record what one has seen in two dimensions as objectively as possible.

*Exemplar:* The pupil should make a drawing of a simple clay form so that another pupil can reconstruct it in the original material.

**19** To discover and understand the environment through direct manipulation of it.

*Exemplar:* The pupil should make a detailed study of one square metre of ground in any form whatsoever (e.g. drawing, listing, collecting, talking, photographing), and then reorganize this information to re-create his own square metre of environment.

**20** To explore media so that they can be understood and used appropriately.

*Exemplar:* The pupil should explore the numerous ways in which the form of a piece of clay can be altered; how long a coil of clay can be made which can be supported from one end; how many holes can be made in a piece of clay before it collapses; how thin a piece of clay can be made; which objects make the best impressions in clay.

**21** To externalize our personal reality through the manipulation of materials.

*Exemplar:* To create using any available materials, a small environment which expresses the personality of the person within it. A personalized space capsule.

It is worth noting that nearly all of the exemplars are stated in terms of media/form. This does not mean that the emphasis is on these two aspects at the expense of idea/content. It is, however, difficult to comment on the latter aspects of the pupil's progress unless one is in direct contact with the process.

## Starting points

These starting points are set out under the three headings described in Chapter 2 and set out in Figure 4.1. These are in note form only and are given to indicate the nature of the activity. Art teachers should be able to relate their own ideas with the examples given.

### THE FIRST AND SECOND YEAR APPROACH

With or without some knowledge of the stages of children's visual development, most teachers seem to agree that the first and second years of secondary education are the time for transmitting a basic understanding or experience of art. The work which the children have done in their primary schools is often discounted. The general expertise of the primary school teacher is not recognized as having any validity by the specialist art teacher who takes upon himself to lay the foundations of art for pupils he meets as children and who leave him as young adults. This is not the place to ask art teachers to change their view of first year pupils. The general misunderstanding which exists at each level of education about the others is too large a problem to deal with here in depth, but it may be worth making some points which may open up the possible range of solutions.

The form of art education in primary schools is very different from that practised in secondary schools. The art teacher who expects a child who has just left primary school to have had experience in a wide range of craft techniques and materials and positive experiences in design will usually be disappointed. It is often thought that this deficiency stems from the inability of the primary school teacher to deal with specialist ideas and skills. While this is sometimes true, it may also blind the secondary school art teacher to the useful knowledge which has been fostered during the pupil's previous 6–7 years in school. This may not have given the child the expertise that the art teacher sees as a necessary foundation for a broad art education but the pupil may have developed other qualities which could prove of great value to him when moving into another 5–7 years of work. In Chapter 8 the period from 8 years to 13 years is seen as one where the child is concerned with concrete operations and with direct manipulation of experience. The environment is explored, questions are asked, solutions are proposed and tested. The child

operates directly. He does not detach himself from the area of the problem, he rarely abstracts and formalizes it. The problems and the solutions derive from experience and action.

British primary schools are noted for the range and scope of their work. There is a considerable emphasis on a child-centred approach; much of the work is based upon individual or group enquiry. This is not usually confined within a particular subject discipline. A project may include written work, mathematics, graphs, diagrams, cognitive as well as expressive visual study, and the use of a variety of materials and techniques. Links may also be made with other areas of knowledge and experience if and when appropriate. In this approach, art and craft are often seen as a means of enquiry. Art is used to communicate information and express the child's response to experience. Art is seen by the teacher as a part of the range of languages and skills available to the child in his whole development.

These qualities of the enquiring child are sometimes rejected by the secondary school teacher who is looking for a child in his own image, and yet these qualities of excitement, exploration, curiosity can be of considerable value to the secondary art teacher. They can be used to teach those new skills and experiences which are held to be of paramount importance to the developing child. The new pupil has already learnt, in the first eleven years of his life, more than he will ever learn in the future. It would be a tragic waste if this was ignored in the secondary school art department and each new child taught as if he were devoid of any real art experience. What we are looking for may not be present, but what is present must be seen as valuable.

There are two basic approaches to the general foundation course in the first and second year of secondary art education. The first is to set up a course which gives the pupils the opportunity to experience a wide range of materials and develop a wide range of skills related to subject matter appropriate to the children's interest. This usually means painting, drawing, printmaking, claywork, construction, textiles and some other activities depending upon the particular expertise of members of the art staff. The second approach is to deal with the basic language of art and design. Here the children are given experience in manipulating colour, line, texture, composition, form and design. This is then related to and built into their own expressive activities. The argument is that until they understand the

forms of visual expression they lack the means to express themselves.

The first approach is more in line with the stage of development usually associated with first and second year pupils. The second pre-supposes an ability to deal with formal abstract elements and this is usually related to the 13+ stage of development. There are obviously many problems in making decisions about the appropriateness of particular approaches. The debate is so well documented that it is almost daunting (Lowenfeld, 1964; Eisner, 1972). The difficulty is that it is possible to demonstrate that pupils can operate effectively using methods not considered by some to be appropriate to their developmental stage. The main problems arise when decisions about how to deal with first and second year pupils are based upon the interests of the art teacher rather than the needs of the children.

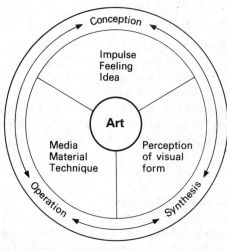

**Fig. 4.1**

FIRST YEAR

*'Material, Media, Technique' starting points*

**1** Get pupils to make the highest free standing structure they can out of four editions of a Sunday newspaper, plus some four inch strips of brown sticky paper.

**2** Using any material they should make a series of easily

duplicated forms. The form of duplication should be based upon the inherent nature of the material. These should be used to construct a design or image. Figurative or abstract forms may be used.

3 Clay manipulation. Children should:

(a) explore the different states of clay (slurry to baked).
(b) see how many ways they can discover to change the shape of a piece of plastic clay.
(c) take one of these ways and develop a form dependent upon the method of manipulation.
(d) explore clay to destruction, i.e. how long can a 'coil' be before it breaks; how thin before it collapses; how hard before cracking; how soft without sticking?
(e) see how many holes they can make in a ball of clay before it collapses.
(f) see how many spikes or points they can pinch into the surface of clay.
(g) make two 'ginger bread' figures about 3–4 cm high. Join them together to create a unity viewed from any direction – wrestlers, lovers, tumblers. This form can be manipulated to abstraction.
(h) develop their own forms from this previous experience.

4 *Surface exploration*    Pupils should explore ways which could be used to record or express the quality of a surface. They can explore the possibilities presented by the following methods: printing; wax crayon rubbing; photograph selection from magazines; plaster casting; clay or plasticine impression; cooking-foil rubbing; latex skinning; words; taped sounds; drawing. They should use one technique to explore several surfaces and several techniques to explore one surface. They can then start creating their own surfaces most appropriate to any form of recording or reproduction.

*'Impulse, Feeling, Idea' starting points*
When dealing with a large group of children, most of these starting points will have to be based upon their responses to the ideas of the teacher or the ideas of others brought in by the teacher or upon their individual responses to a common experience created by the teacher. With smaller groups or individuals, the ideas, impulses and feelings can be more spontaneous.

1 Stimulate ideas, impulses, and feelings through listening to stories and music.
2 Use national or local news stories to motivate personal response.
3 Get children to collect photographic images from magazines.

By cutting and tearing they should reorganize them until the original image is altered to suggest something different. (Identical images given to a group of pupils could be a way of drawing attention to the variety of results.)

4 Suggest they study the similarities and differences within a set of objects, e.g. a terrace of houses, a group of children, cars, shoes. On the basis of what is discovered, propose ideas which allow for differences whilst still retaining membership of a set.

5 Ask pupils to consider a common experience which interests them all, e.g. Christmas, skateboarding, builders, the market. The emphasis should be placed on the crucial element of the experience which arouses the excitement or interest, rather than on a general response containing all elements. This will lead towards a realization that each pupil's ideas, impulses and feelings are peculiarly his own. The differences should lead to an awareness of the pupil's personal reality even when responding to a common social experience.

6 Ask pupils to imagine that a common object, situation or environment is, in fact, something totally different. With this in mind, ask them to draw or paint it, using a particular perspective, style, or distortion to emphasize the new view to be realized. For example, they could draw the school as a prison or a palace; imagine a typewriter as a space city; create a forest of cauliflowers; draw a part of their body as a landscape.

*'Elements of Visual Form' starting points*

1 Ask the pupils to create a feeling of falling, braking or swaying by using a series of lines.

2 They should use a series of spots to create two designs, one exploding, one imploding.

3 Suggest they draw from observation or create a composition of buildings receding from 'close by' to 'far distance'. They should then make a series of copies of these and experiment with the use of colour to enhance the sense of nearness and distance within the composition. Compare, contrast, and discuss the results.

4 Encourage them to analyse the form and structure found in natural objects. This may require the objects to be dissected or sectioned. The main purpose is to discover the inherent order found within the natural design. Fruit, vegetables, shells, plants, and flowers are ideal for this exploration.

**5** Reverse the discoveries made in **4** above to create new types of organic forms in two or three dimensions. (A good parallel would be the molecular structures created by scientists.)

*'Material, Media, Technique' starting points*

**1** Using common objects, get the children to transform them so that they have a different use or meaning. For example, a large stone could become an island whose physiognomy is suggested by the stone's shape; a polystyrene packing form could become a new town centre; a dead branch could be transformed into a living creature. The emphasis here should be on the continuous process of transformation rather than on the single change and everything else left to chance.

**2** Related to **1** above suggest pupils use objects they have found in animated shadow puppet shows, where the objects are manipulated to suggest particular characterizations. Extend this by the use of coloured lights and constructed 'shadow puppet' forms.

**3** The children should experiment to find the limitations which the materials impose upon the designer. They could make a cloth car, metal food, a string man, or clay waves.

**4** Explore with the children the possibilities of relief printing by (i) reductive method, i.e. the removal of surface as in lino cutting, card cutting, hammering, and beating, and (ii) an additive method where the original surface is built upon by adding appropriate materials like paper, cardboard, string, thread. The concern here should be with three main aspects:

(a) the use of different materials to create printing surfaces,
(b) the effect of changing the surface and printing in a sequence of different colours and/or tones,
(c) the positive/negative implications of the process.

**5** Ask the pupils to develop ways of making similar clay forms, e.g. hollow spheres, tubes, domes, corrugations. They should make a series of identical forms and, with the minimum of manipulation, create a series of distinctly different objects. The object can be functional, figurative, or decorative. The emphasis should be on economy of effort and maximum ingenuity.

*'Impulse, Feeling, Idea' starting points*

**1** Suggest the children change the character of a particular environment by changing the elements of its design. This can be done with an actual environment like a classroom, stockroom, stage, patio, or it can be suggested by the manipulation of magazine photographs. The aim is to draw attention to the nature and quality of the man-made environment; what man creates effects how he responds.

**2** Ask the pupils to imagine themselves in a different situation. What would the effect be upon them and how would they respond to it? For example, how would they view the world if they were 10 centimetres or 10 metres tall? How would the world be if all people had wings and could fly? The object of this exercise is to emphasize how individuals respond to change in their own way.

**3** Ask the pupils to make an objective study of a limited area of their environment. Through observational drawing and analysis ask them to communicate and express their understanding of it. Then ask them to demonstrate how it would look if they had full responsibility for all decisions made about the area. The emphasis should be on visual awareness of the environment but this must be related to their feelings about the place.

**4** Ask the pupils to draw a friend in the class and, by the use of colour, subtle distortion, emphasis, background, proportion, enhance the qualities most appreciated by the observer and play down those aspects which are not seen as beneficial.

All of the above exercises are designed to draw attention to the unique value of each individual's perception of reality.

*'Elements of Visual Form' starting points*

**1** Ask the pupils to explore the effects of coloured lights

(a) directly upon objects,
(b) against a shadow screen.

Extend this into the mixing of coloured lights.

**2** They should explore simple animation techniques to discover how the impression of movement can be created by viewing static elements in a time sequence. Flick books dealing with abstract elements of design are simpler in the first stages than figurative work.

**3** Get the pupils to design a series of new signs for common

directions like 'Go straight on', 'Turn left', 'Do not run', 'Keep left', 'Boys' toilets', 'Male staff toilets'. Three series of signs should be considered:

(a) Figurative signs which are graphically explicit.
(b) Symbolic signs where the meaning is expressed through an under- standing of its form
(c) Arbitrary signs where the meaning has to be learnt by the user.

The Highway Code is a good source of examples for all three. An example of (a) is the car sliding on the slippery road; an example of (b) is the left turn or roundabout sign; an example of (c) is the red triangle or circle at the top of a road sign which indicates whether the information given below is an order or a warning.

4 Ask the pupils to explore the effect of roughly horizontal lines placed in a variety of positions on pieces of paper when viewed as landscape. They should try this with paper of both 'portrait' and 'landscape' proportions, and extend the idea by varying the tone and colour of the upper and lower sections of the paper. Evaluate the effects in terms of mood and dynamic.

THE THIRD YEAR APPROACH

This stage of secondary education is recognized by many teachers as the most difficult in terms of content and motivation. Some reasons for this can be deduced from a study of publications on child development (see Chapter 9). The motivation of youngsters moving into the crisis of adolescence and what Robert Witken calls 'the representational crisis' is a major problem (Witkin, 1974). Many art teachers see the solution in the creation of a course dealing with a narrow area of activity but in considerable depth. There is a ten- dency to make the area of activity craft-based and ask pupils to explore the potentialities of printing or clay, using the pupils' own interests as the content matter.

The situation is further complicated by the pattern of secondary education. The third year is usually the last year when art is viewed as part of the general curriculum. In the fourth and fifth years it is seen as an option which is tied to examinations but one which is taken by 'drop-outs' from other subjects. The third year is the year of transition from child to adult. Pupils no longer respond to the type of work done in the first and second years and look on it as 'kids'

stuff'. On the other hand, they want to be able to produce work which is generally acceptable to their peers and which lies within the framework of art as understood by most adults and demonstrated by the mass media. The course for the third year must take these factors into consideration whilst accepting that, for at least half of the pupils, this will be the last art they will do at school.

Mindful of the twin constraints of child development and secondary organization, few alternatives are open. Some art teachers fight vigorously to make art an essential part of the core curriculum up to the fifth year. Others feel that the only way to make their subject credible is to demonstrate their success with pupils through the examinations system. Some look upon art examinations as proof of their ability to create viable schemes of work in art for pupils rejected by others as non-examinable or even unteachable. Any decisions made by an art teacher about courses for the third year and above will inevitably be more influenced by the constraints imposed by the structure of the school than by any of the ideal suggestions made in a book of this kind.

In setting out starting points for the third year, it is worth considering that drawing skill appears to be important for those pupils intending to continue with art in the fourth and fifth years. It could also be a means of motivating pupils passing through a 'representational crisis'. Drawing is a skill essential for most forms of visual communication and expression. It does not fit into any particular segment of the art circle shown in Figure 4.1. It could be looked upon as an important way of approaching all aspects of form, media, and ideas. Many teachers despair of teaching the third year how to draw. However, this problem could be solved if an appropriate course could be devised. It is worth keeping in mind that at this age pupils are more able to respond to abstract and formal concepts. They may be more willing and able to tackle drawing skills than before. Further work needs to be done on the teaching of drawing during this period of transition. It is not often realized that a mixture of drawing systems are used by pupils at this stage of development. It can be confusing, therefore, if only formal perspective is seen as acceptable to the teacher. There may be a need to develop an approach using a clearly articulated range of drawing systems (Willatts, 1977).

There are a number of good books which deal with design and craft. Some are suitable for this stage of development and above, such as de Sausmarez (1964), Green (1974), and Baynes (1976).

This list could be extended into pottery, printmaking, and other craft activities. The important point to consider is the appropriateness of any technical book to a particular age range. Maurice de Sausmarez's book is an excellent example of this. It is a carefully considered discussion of the need to understand how to use form dynamically. It is not written as a textbook or aimed at a particular age range. Many of his ideas have been used with children of 11 and 12 with some apparent success. Whether the work is relevant at this age is open to debate. In general art teachers need to consider more carefully the appropriateness of an activity at a particular stage of development.

This point is made here as the majority of serious practical books available to the art teacher fall within the area of design and craft. Most of them do not relate specifically to an age range but most of them appear to be suitable for pupils of 13+. There is a dirth of books dealing with starting points and motivation related to 'Impulses, Feelings, and Ideas'. This could be one reason why work in the third year tends to move towards the more clearly defined practical workshop activities. Teachers often feel that children at this age become less imaginative and less creatively responsive. Perhaps, as well as the study of drawing courses mentioned above, there is also a need to consider forms of motivation for more personal graphic, fine art work. Bob Clement in a recent lecture to a group of teachers said that there was a strong tendency for the content of school art activities to follow the seasonal festivities from Christmas to Spring and Easter with a largish jump to Autumn, Fireworks Night, Halloween, and back again to Christmas. Third-year pupils having passed through this cycle for nine years may require more dynamic motivation before they can be justifiably condemned as unimaginative.

THIRD YEAR

*'Material, Media, Technique' starting points*

1  Ask the pupils to make a construction out of paper straws which will support the weight of a one pound jam jar full of water between two points 40 centimetres apart.

2  Get them to construct out of clay a hollow form with entrances and exits to be used as a bird table or nesting box. This should be secure from predators and designed to enhance a particular part of a patio or garden. This problem is designed to encourage the pupils to

build upon existing experience of clay and to create a new form. At the same time the pupil is required to operate within the functional requirements of the problem.

3 Ask the pupils to draw the house and garden opposite their home or school. (Any drawing system is acceptable.) They should then make two lino cuts from the same drawing; one by using the cut-to-waste method, the other using a key line block with a series of cardboard blocks to print colour underlays. Compare and contrast the results. On the basis of this work ask them to draw another image and develop an alternative or composite method for printing it.

*'Impulse, Feeling, Idea' starting points*

1 Place a series of mass produced objects, loosely associated with the interests of this age group, into a box marked 'ploy'. (The original objects could be selected and listed by the class then grouped by the teacher.) Divide the class into groups of four or five. Ask each group to design an object, environment or light sound show out of the ideas engendered by the objects. The type of things in the box could be Green Shield stamps, prefects badges, pop records, pin-up photographs, lapel badges, snapshots, tickets, monopoly money, newspapers, 'free' offers, a bunch of keys.

2 Ask the pupils to respond to a series of set locations as if they were aliens from another planet without knowledge or preconceptions about themselves. Suggested locations: a telephone booth, the store room, the gymnasium, a car or lorry.

3 Give a group of pupils twenty randomly chosen photographs/colour slides and ask them to create a tape/slide sequence similar to a television news insert. All the slides need not be used. Alternative slides could be constructed and included once the story line is developed.

4 Ask the pupils to draw a part of the environment with a particular characteristic. Whilst drawing they should elaborate the important elements and underplay others to emphasize the particular quality they have selected.

5 Ask them to create a poster, display or miniature museum which will communicate who they are now, what interests them, what aspirations they have. They should design this to be locked away for approximately fifty years for their grandchildren to study when they are of similar age.

*'Elements of Visual Form' starting points*

1 Suggest the pupils create an object or environment which increases, decreases or relatively changes the natural scale of things to create a new world, e.g. Lilliput, 2001 space age, King Kong, Tom Thumb. The work need not be figurative, the pupils should be introduced to optical illusion and introduced to mirror distortion or wide angle lens.

2 Get them to change the appearance of a face by altering colour, shape and proportion. This can be done starting with neutral, naturalistic masks or photographs of faces from magazines or actually on a face with make-up pencils. A good starting point is to invert the eyes and mouth on an existing full frontal photograph of a face.

3 If stage lighting and simple white flats are available, ask pupils to arrange lights, colours, shapes to create spaces representing 'the dungeon', 'the desert', 'the courtroom', 'the tower'. Extend this to become 'the freezing dungeon', 'the blazing desert', 'the jester's courtroom', 'the princess's tower'.

THE FOURTH AND FIFTH YEAR APPROACH

The starting points at this stage will be largely determined by the examination syllabus. Even so, the pattern suggested above for the first three years could be useful in ensuring a balanced approach in the final two years. This is particularly necessary when pupils decide upon the main area of their study for an extended period of time. Whilst monitoring, motivating and encouraging, the teacher should make sure that the pupil is working reflexively. This means that, as the teacher recognizes an over-emphasis on, say, 'Media, Material, Technique' and a lack of concern for, say, 'Impulse, Feeling, Idea', comments and suggestions could be made to move the pupil back to the weaker area *through the work done in the stronger area*. This balancing of direction and drive is probably the teacher's most important function at this stage. This three-part emphasis gives direction and meaning to the teacher's effort. During these senior years, it is helpful to the student if the threefold structure used by the teacher is made explicit to the pupils so that eventually they can monitor themselves. This growing independence of the pupil from the teacher fulfils one of the essential aims of art education, namely the production of an independently thinking, self-

motivating, young adult. In the end the pupil and teacher should find they work together with mutual understanding of their freedom and dependency. This is facilitated if the framework for the art teaching strategy becomes the framework for independent art work for the pupil.

## GENERAL NOTE FOR THE READER

It is most important that the starting points set out above are seen as *examples* of a type of lesson. They are designed to show what each part of the three sectioned circle of the nature of art *could* mean in practical terms. They should not be seen as ideal or complete teaching notes. The writer is fully aware that they may not be appropriate to many teaching styles but without this exemplification the suggested framework might seem to be an abstraction unrelated to the real problems of teaching.

# 5 The syllabus based upon objectives

**The objectives model**

Ralph Tyler has suggested a useful structure for the study of the curriculum. If used by the art teacher, it has the advantage of being readily understood by teachers of a wide range of other subjects. This could clear the road for the negotiation of art as a part of the whole curriculum.

> The rationale developed here begins with identifying four fundamental questions which must be answered in developing any curriculum and plan of instruction. These are: (1) What educational purpose should the school seek to attain? (2) What educational experiences can we provide that are likely to attain these purposes? (3) How can these educational experiences be effectively organized? (4) How can we determine whether these purposes are being attained?
>
> (Tyler, 1944, p. 1)

To simplify they will be called (1) objectives, (2) content, (3) method, (4) evaluation as shown in Figure 5.1.

AIMS

An *aim* is a statement of the general outcomes that one hopes to achieve. Whether implicit or explicit they are derived from value judgements about individuals, knowledge, and society, and so on. There is less disagreement between art teachers about general aims than about specific objectives.

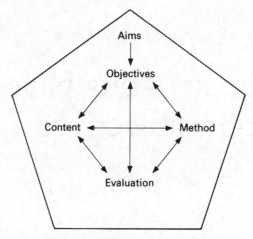

**Fig. 5.1** The objectives model.

OBJECTIVES

Objectives are directives formulated to achieve the general aim. They are more precise than aims and usually specify behavioural changes that will take place if the objective is achieved. Objectives in art are not always related to prescribed changes in behaviour but have other outcomes not shared by more cognitive subjects like mathematics, science and language. Elliott Einser (1975) has gone some way towards helping the art teacher to design a syllabus within the objectives model by defining three types of objectives.

**1** *Behavioural or instructional objectives*
These are 'statements that describe the specific behaviour a student will be expected to perform in a particular content or material'.

Behavioural objectives are, firstly, a description of the student's behaviour, not a description of what the teacher is doing. Secondly, they should define the content in which the behaviour is to be displayed. Thirdly, the objectives should be sufficiently specific to enable one to recognize the behaviour if the student is able to display it.

In art, these objectives are relevant in the processes used to develop certain skills which help pupils to reach personal solutions.

**2** *Expressive objectives*

Expressive objectives differ considerably from behavioural and instructional objectives. An expressive objective does not specify the behaviour the student is to acquire after having engaged in one or more learning activities. An expressive objective describes an educational encounter: it identifies a situation in which children are to work, a problem with which they are to cope, a task in which they are to engage; but it does not specify what they are to learn from that encounter, situation, problem or task. An expressive objective provides both the teacher and the student with an invitation to explore, defer or focus on issues that are of peculiar interest or import to the inquirer. An expressive objective is evocative rather than prescriptive.

The expressive objective is intended to serve as a theme around which skills and understandings learned earlier can be brought to bear, but through which those skills and understandings can be expanded, elaborated and made idiosyncratic. With an expressive objective what is desired is not homogeneity of response among students but diversity. In the expressive context the teacher hopes to provide a situation in which meanings become personalized and in which children produce products, both theoretical and qualitative, that are as diverse as themselves. Consequently, the evaluative task in this situation is not one of applying a common standard to the products produced but one of reflecting upon what has been produced in order to reveal its uniqueness and significance. In the expressive context, the product is likely to be as much of a surprise to the maker as it is for the teacher who encounters it.

(Eisner, 1975)

**3** *The design objective*

The design objective is to take a problem and within the constraints that accompany it, arrive at one or more solutions that provide a satisfactory resolution. The inferred outcome is to conceive of ways in which the problem can be solved and to select the best solutions. Usually the constraints are defined with the problem, but the forms the solutions can take are, in principle, infinite.

A course design for art education could contain examples of all three types of objectives. Once the simple definition of objective has been expanded to contain the three distinct forms described above the viability of other aspects of Tyler's Objectives Model is brought into question. For this reason it was decided to suggest an alternative method more suited to the nature of art as a content area. Readers may ask why, if an alternative model was to be proposed, it was

necessary to explain and criticize the Tyler Model. Most teachers placed in the position of having to explain, justify or criticize curriculum will find that they are expected to relate to some sort of behavioural objectives model; if they respond with an alternative it might be assumed that they are doing this out of ignorance of the generally accepted model. In order to clarify the case for all concerned it is best to explore the traditional directions before proposing a new approach.

METHOD

Tyler (1949) defines this as the organization or management of effective educational or learning experiences. It includes all forms of interaction between pupil, teacher, and resources. The patterns of interaction can be concerned with the direct transmission of knowledge or the processes associated with it.

The transmission of a body of knowledge can be associated with any aspect of art, i.e. social, cultural, technical. The transmission of knowledge in art is intended to make the pupil aware of the sum of all human experience and knowledge in art, or as much as can be absorbed appropriately. By such transmission, it is hoped that the pupil will be able to comprehend the field and operate within it.

The process of art is concerned with the way that we learn.

> The development of skills and processes related to learning, using analytic, productive, and expressive thinking, together with skill and processes concerned more directly with emotion, motivation, values and interpersonal relationships.
>
> (Cole, 1972)

> All of the random or ordered operations which can be associated with knowledge and human activity ... it is the underlying scheme which provides order and direction.
>
> (Parker and Rubin, 1966, p. 2)

CONTENT

Content is usually defined in terms of a body of knowledge, as information, as a description of events, as process and technique or as problems associated with particular segments of human knowledge together with the media and materials used in pursuing them. For art, such a definition could be disastrously limiting. Art as

content, in this model, needs to be seen as the synthesis of visual and tactile experience culminating in the integration of personal perception, thinking, doing and feeling.

## EVALUATION

Evaluation is the measurement of the competence or capacity of students to achieve objectives or inferred outcomes. Evaluation implies some degree of judgement. (Assessment is a more limited form of evaluation suggesting measurement against a norm which contains limited value judgement.) Dewey recognizes the special problem of evaluating the arts.

> If there are no standards for works of art and hence none for criticism (in the sense in which there are standards of measurement), there are nevertheless criteria in judgement, so that criticism does not fall in the field of mere impressionism. The discussion of form in relation to matter, of the meaning of medium in art, of the nature of the expressive object, has been an attempt on the part of the writer to discover some of these criteria. But such criteria are not rules or prescriptions. They are the result of an endeavour to find out what a work of art is as an experience: the kind of experience which constitutes it.
>
> (Dewey, 1958, p. 309)

However, there are social, cultural and aesthetic attitudes which can become the norms against which work can be evaluated. It is very difficult to avoid them when evaluating work whether it is one's own work or that of others. The norm is not necessarily avoided by self-evaluation, it depends upon the degree of socialization. The norm is defined by the social group whose norms one has accepted and adopted. The norms of artists are those that are negotiated and agreed within a group of artists. Or art could be judged by the negotiated norms of 'Coronation Street'.

In a classroom the evaluation can be *teacher evaluation* against a set of personal, social or cultural norms or attitudes understood by the teacher and transmitted to the pupil. On the other hand it can be *self-evaluation* by the pupil in terms of how he measures his outcomes against his intentions. This can still be strongly influenced by the social conditioning of friends, the mass media and respected adults.

Both forms of evaluation can either be made in terms of continual assessment throughout the process (formative) or as an assessment of the final outcome (summative).

### THE PROBLEM OF USING THE OBJECTIVES MODEL FOR ART

It is generally recognized by writers like Eisner and Stenhouse that Tyler's Model poses problems for certain areas of the curriculum. Objectives and evaluation have to be opened out and redefined to accommodate the arts. Content and method become confused and merge into one another.

> I am arguing then that one of the main functional advantages of the disciplines of knowledge and of the arts is to allow us to specify content, rather than objectives, in curriculum, the content being so structured and infused with criteria that, given good teaching, student learnings can be treated as outcomes rather than made the subject of prespecifications. Disciplines allow us to specify input rather than output in the educational process. This is fairer to the needs of individual students because relative to objectives, disciplined content is liberating to the individual.
>
> (Stenhouse, 1970/71)

I accept that for some art teachers the Objective Model may be the most suitable structure for their art syllabus. If the majority of departments are rationalizing their activities in this way it could be advantageous to use the same form. But I suggest that the Process Model in the following chapter is a more appropriate form for an art syllabus, as it allows art to describe its concepts, processes, and criteria in a more natural way.

# 6 The process model for the syllabus

It is possible to define a structure for an art syllabus which is not objectives-based. Peters (1975) argues that education implies the transmission of what is worthwhile to those who become committed to it. Education is being involved in worthwhile activities which have their own built-in concepts of excellence, which are appraised through the standards which are inherent within them rather than because of what they lead to. In other words the activities are worthwhile in themselves rather than as means towards objectives.

Art, like other forms of knowledge, has its own structure of concepts, procedures and criteria. It is through an understanding of these that art can be comprehended as a whole, but there can be no *finite* understanding of art for at any level, the concepts, procedures and criteria are the focus of speculation not the object of ultimate mastery. This is part of the essential nature of the subject. Art is not a body of knowledge, a skill, a set of rules, a process. The sum of all our visual knowledge is not only what we know, but the way we know it and respond to it. It is the commitment to this idea which forms the crucial concern in art.

To create a course design or syllabus it is necessary to identify activities which seem to have inherent worth and are accessible to the judgement and understanding of others. These need to be set out in a form which is acceptable to art teachers and their colleagues in other disciplines. The process model appears to satisfy both requirements.

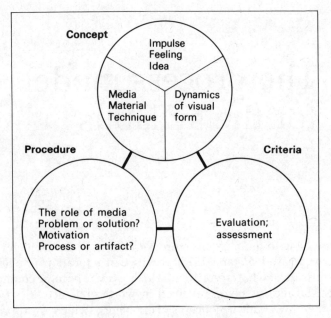

**Fig. 6.1** The process model.

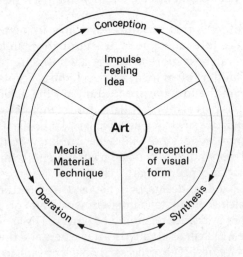

**Fig. 6.2**

## The concepts of art education

**Concept** n.   a general notion, a thing conceived.
**Conceive** v. t  to form in the mind; to imagine or think; to understand; to grasp as a concept; to express.

(Chambers Dictionary, 1972)

Art education is concerned with the development of the senses as our way of 'receiving' our world, and the process that we use to symbolize, externalize, understand, order, express, communicate, and solve its problems. I recognize three main facets of art education. I am using the same elements with which I defined art in Chapter 2 but I will now relate them to art education operationally.

### IMPULSES, FEELINGS, AND IDEAS

These are concerned with the relationship between our inner reality and our sensory experience of the environment, together with any outcomes of this relationship. Art is founded on the belief that sensory experience is the best way of knowing, thinking, and feeling.

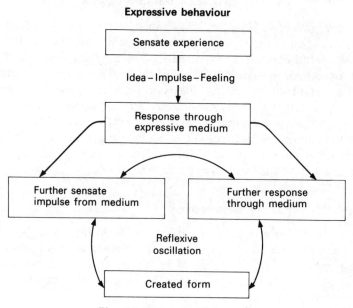

**Fig. 6.3** Expressive behaviour.

It is also the best means of receiving, organizing, understanding, and transmitting our own impulses, feelings, and ideas. Robert Witkin (1974) has set out a clearly defined structure of how he sees expressive behaviour operating and this is shown in Figure 6.3.

Expressive behaviour is also explained in a Schools Council working paper.

> A conceptual framework is presented which distinguishes between subject and object knowing, expressive and impressive action. It is based upon the notion painstakingly developed in the opening section of (*Witkin's*) book, that all action is 'projection through a medium'. Expressive action is the projection of an expressive impulse through an expressive medium – such action constitutes subject knowing. Expressive action is the means by which an individual comes to know the world of his own feelings, of his own being – 'a world that exists only because he exists'. Impressive action is its exact counterpart and provides the individual with the means of knowing the world of objects – 'the world that exists whether or not he exists'. Subject knowing is *subject – reflexive action*: *feeling impulse* projected through an *expressive medium* yields *feeling form*. Subject-reflexive action is proposed as the common experiential root from which all the arts spring – subject knowing is their common goal.
>
> (School Council working paper 54, 1975, p. 57)

Victor Lowenfeld (1964, p. 258) defines two types of approach to the perception of experience. *The haptic type* is subjective and intimately bound up with the experience of self through visual, tactile, and kinesthetic sensation. *The visual type* uses the eyes as intermediaries for the experience of the external world. These definitions are at the extreme ends of a continuous range of mixtures of the two types. It would be extremely unlikely for a perfect example of either type to be found in practice. The *response* to experience can also be haptic or visual. The pupil who perceives haptically will respond best in a haptic way and vice versa.

## MEDIA, MATERIAL, TECHNIQUE

These are the means through which our impulses, feelings, and ideas are transmitted and expressed. This does not mean that their role is passive. They will interact with our inner reality through the senses. They oscillate between being the medium for expression and the source of that expression.

The range of possibilities is almost infinite but art education has

already selected some elemental materials and techniques which appear to present the maximum opportunity for exploration and manipulation. Clay, wood, paper, paint, cardboard, mark makers, and textiles are commonly found in the art room. Such techniques as painting, printing, casting, modelling, drawing, forming, and montage have become part of the basic language for expression. There is a tendency, often arising out of confusion about aims and objectives, to introduce obscure methods and materials which offer little more than novelty value. No media or techniques should be discounted as totally inappropriate, but consideration should be given to the value and purpose behind their use. If our sole objective is the creation of aesthetically pleasing artefacts produced by careful consideration of materials, then macrame could be a useful activity. Likewise painting could become a pointless exercise if it were concerned only with the reproduction of existing images. It is the interaction of media, materials, and techniques to form a personal imagery that gives significance to their use. Traditional materials have been tested by time. Clay work and printmaking are still common activities in our art rooms. Typography, bookbinding, and weaving are no longer pursued with the same excitement as in the 1950s and 1960s. The waste products of twentieth-century life can offer pupils opportunities for transformation that were virtually unrecognized twenty years ago.

Techniques and materials must be related to the whole art experience for them to play a significant function in art education. If we concentrate on pure technique, we run the risk of duplicating the work done by handicraft and design teachers and neglecting the other crucial aims and objectives associated with art.

## THE PERCEPTION OF VISUAL FORM

This is the means by which the media, material, and techniques are organized in order to convey the idea-impulse-feeling. Again, this does not imply a merely servicing role. The elements of visual form have an inherent dynamic which stimulates interest in the other two facets of art education. Line, shape, colour, tone, space, and texture are the elements that comprise our experience of the visual-tactile world. It is sometimes useful to define, isolate and manipulate these elements to discover their dynamic potential. It is through our awareness of these elements that we realize the potential of

materials and the forms through which ideas are expressed. The perception of the world through, for example, line and colour elements is a powerful stimulator of impulses, feelings, and ideas. The exploitation of these elements is the means used to give appropriate form to the idea through the material.

As I have said above, each one of these three facets is not in itself art. Certain artists will emphasize one aspect, but it is not possible to create an art form without the use of all three elements 'reflexively'. A simple example of the use of 'reflexive' in this context is the handling of a piece of clay. The input on this occasion is at the operational level but other examples could be given where the input is conceptual or perceptual. A hand holding a lump of clay senses its wetness and coolness. If it moves over the clay it finds this to be plastic and malleable, i.e. it retains and records the movement of the hand over the clay. The manipulator's fingers and eyes are conscious of the changes in shape and he, himself, becomes aware of the potential for change and the creation of new forms. The changing forms engender ideas, impulses, and feelings which, in turn, create new possibilities for further manipulation. I would hope that, at the highest level, it would be possible for all aspects of art education to be taught reflexively.

> The idea does not exist before the form and the material does not attain form without impulse. Idea is made in the interaction between the individual's feeling, experienced as impulse for release, and the medium which he works into the form that releases it.
>
> (Witkin, 1974)

## The procedures of art education

In discussing procedures, I have selected a few crucial aspects for consideration. It is up to each teacher to decide what he intends to do in the classroom with his pupils, but there are important guidelines within which each teacher must locate his particular approach or attitude.

### THE ROLE OF MEDIA

Intelligence can be seen as organized behaviour, where the individual adapts to the objects which exist in the world around him. The individual (in the case of art education, the pupil) uses

media to adapt his experience so that he can first understand it and then use it as a means to furthering his understanding.

Experiencing the world of objects, or experiencing the world through objects, creates sensation, emotion, and disturbance. The very existence of a person disturbs the world or environment. In order to be able to relate to the world the individual must order his sensory experiences so that he can become adaptable, but there would be no motivation to do this without the stimulation of sensory experience. For the pupil, art is the use of media to organize sensory or subjective experiences (see Figure 6.3).

There are two kinds of media – impressive and expressive. 'Impressive', media are used to impress the objective world on the pupil's consciousness. They are arbitrary and have no direct relationship with the initial experience. The written or spoken word has no direct relationship with the object that evoked it. The relationship between the two is arbitrary. The purist form of impressive media is algebra. 'Expressive' media are used to express the pupil's sensory experience of an object by directly relating or recalling the experience. In this case the medium directly resembles the experience of the object. Art is concerned with expressive media because the media are used to evoke the original sensory experience: for example, in landscape painting, colours, lines, shapes, textures and form are used to evoke, recall and re-create the sensory experiences which stimulated their use. The response through the media is as personal as the initial sensory experience. The object behind the use of expressive media is to create expressive form, that is, to give shape to the response through the use of media.

In summary, the initial sensory experience creates an impulse to probe and explore. Media are used as a means of responding to ideas, impulses and feelings which have originated from the media or have arisen out of a disturbance of the world by other means. In either case, the act of extending the experience through the media evokes further responses, which feed back to evoke further media and evoke further experience of it. Interaction stops when impulse from the media and response to it become one and the same.

## THE PROBLEM OR SOLUTION CENTRED APPROACH?

The argument between supporters of child-centred and academic approaches in education goes on at a number of levels, but we want to

explore more fully here what appears to be at stake in the controversy about modes of teaching and learning. Inquiry-based teaching is said to be problem-centred, that is, it is concerned with the process by which knowledge is acquired and applied. Instruction is often said to be solution-centred in that it sets out to transmit the products of inquiry in as efficient a way as possible. Both views of teaching ascribe authority to the teacher, but the nature of the authority is different in the two cases. Instructional teaching sees the teacher as being in possession of bodies of knowledge or technique; the object of teaching is to put the pupil as efficiently as possible in possession of the knowledge and competence possessed by the teacher. Instructional teaching does not, however, necessarily put the learner in a passive role, nor does it rest simply on 'talk and chalk' methods (a variety of audio-visual aids, for example, can be employed to good instructional effect). Instruction would seem to be the most appropriate mode of teaching straightforward information or techniques. Inquiry teaching, by contrast, faces both teacher and pupil with problems of evaluation. Together they tackle problems (say of design or human conduct) to which there are no ready-made solutions, but only criteria of judgement. In this situation the teacher's authority rests upon his ability to design problems and help pupils develop appropriate methods of inquiry.

(Schools Council Working Paper 53, 1975, p. 38)

The art teacher will be primarily concerned with stimulating ideas, impulses, and feelings within the pupil through his contact with sensory experiences. To avoid too much prescription by the teacher, the starting point needs to be a problem arising out of the pupil's sensory experience of the world. This may be a problem defined in terms of material, form, space, situations, or people. The purpose of using a problem located within personal experience to stimulate the pupil is to create the initial drive and motivation to guide his expressive action. As the pupil develops he will be able to select his own problems through his recognition of the impulses that they engender. He will come to recognize those problems that will stimulate him to further engagement. Dick Field has elaborated on this:

It is interesting to ask how far Art Education appears to be concerned with the development in its pupils and students of this sensitivity to problems from which so much else would appear to follow. Undoubtedly, we have been much occupied with problems of perception, though this has perhaps tended to take the form of attempting to teach children to 'see what is there' as a kind of datum of information on which to build; when

possibly it would be of infinitely greater use to help children to realise that there are many ways of looking and many ways of seeing. We have, too, been concerned with the idea of awareness.

Yet, on the whole, art teachers have felt that it was their duty to select problems for children; not only through choice of subject, but through choice of medium also. Of course there are times when the teacher must intervene; but it would seem that more could be done in a more systematic way, to help children to organize out of the chaos of sense impressions some order, some priorities of interest, and to relate these themselves to expressive or exploratory procedures. Education in this area of experience would appear to be fundamental to individual creative activity.

(Field, 1970)

For the pupil to formulate his own problems he must be aware of the conflicts, inconsistencies, and incongruencies existing within his own perception, as well as the illogicalities thrown up by his awareness of his environment. This stage of problem finding or locating is as demanding and crucial to art education as the solution stage.

First, it would appear that a starting point ought properly to lay out a situation in which the individual can discover the problems which interest him. The development sequence here should be one which gradually clarifies the situation and gives children increasing responsibility for distinguishing their own problems and exploring ways of solving them.

One can see that the process of developing sensitivity to problems is an essential element in differentiating out art as a mode of organizing experience. The child has to learn the kinds of problems which are appropriate; it must be possible for him to push off in 'wrong' directions (if there are such) as he is truly to explore the boundaries of what is art.

Second, it would seem that materials and techniques should be at the service of the child. Of course if the teacher says 'Now we are going to make a painting' this adumbrates an area in which problems are to be found; but unless this is intended it appears likely that the materials required would not normally be decided at so early a stage in the process. Trials might be necessary with a number of media. Possibly a form of development might be towards isolating a problem imaginatively in terms of a medium.

Third, it is clear that often the process of recognizing one's problem will lead directly into attempted solutions. We must be aware that a piece of art is complex, however simple it may appear; that in dealing with a problem, a solution may come, not in one step, but in a number of steps. A single problem can be the subject of a simple or a complex solution. It

might be that one starting point would involve preliminary work in separating out and dealing with a number of problems; or that a problem might present itself as complex, only to be revealed when successive appearances are peeled away as simple after all.

Fourth, it can be seen from our picture of the developing process how essential to it are the twin abilities of fluency and flexibility. One sees, too, that even more crucial than these is the sensibility which enables the continuous necessary evaluation to proceed. At every step sensitive evaluation is the condition of the next step. A great deal of wise and restrained teaching will be required if pupils are to learn how to be consistent in their response and at the same time to retain some confidence in their ability to judge and make decisions on the basis of their own judgements. Art teachers ought to be well-accustomed to this problem; if they would help pupils to be aware of the separate and recognizable steps in the process, their task would grow easier.

This spotlights the fifth point that must be made; the pupil operating as artist must 'think' in his medium; his subject matter is, in Dewey's words, *'the qualities of things of direct experience'*. (Dewey, 1934)

(Field, 1970)

## MOTIVATION

The selection of the problem and the pupil's response to it start the whole creative process moving. In the model being used here (Figure 4) the procedures operate through the perception of, and sensitivity to, the three interrelated elements of art, as described in the conceptual framework, i.e.

(1) Idea, Impulse, Feeling
(2) Material, Media, Technique
(3) Perception of Visual Form

It may be necessary on certain occasions to emphasize one aspect but its development should not be possible without reference to the other two. The starting point for an activity could originate in any of the three, but inevitably any development would require a consideration of the others in terms of the total concept. Reflexivity suggests an interdependent oscillation between the three elements of the conceptual framework. As I have stated previously, art is a totality and consideration of possible decisions is made within the model described above. Starting points tend to be located in one of the three elements but as activity develops the parts become more interrelated and lost in the totality of the art activity.

In the final chapter of *The Intelligence of Feeling*, Robert Witkin formulates what he holds to be the three 'invariant' phases of the creative process and gives some guidance to the teacher as to how to enter the expressive act of the child and assist its development 'from within'. These he designates:

## The setting of the sensate problem
The teacher enters the creative process by selecting and stimulating an appropriate sensate problem – that is to say, he makes sure that there is an impulse within the child to motivate and guide his expressive action. Of the sensate problem Robert Witkin writes that quite simply, all sensate disturbance whether great or small, pleasant or unpleasant, is a problem in so far as it makes demands upon us to structure our particularity.

He then proposes a tentative and intriguing model to account for the child's developing structural capacities in the realm of feelings and, in the light of that model, suggests the criteria which should determine a teacher's selection of appropriate sensate problems. The problem cannot be regarded as having been set, he says, until its structural character (contrast, dialectic or harmony for instance) is a felt experience of some intensity.

*The making of a holding form* ... that will 'encapsulate only the essential movement of the sensate impulse and ... hold that movement in consciousness for the duration of the expressive act ... a form that captures the structural characteristics (of the impulse) in their barest essentials. It is the essential gestalt of the disturbance that is held in the holding form.'

The purpose of making a holding form is to enable the pupils to maintain contact with the original impulse in the ensuing creative action. Once the impulse is lost then all hope of resolving the original problem in feeling form is lost too.

*The movement through successive approximations to a resolution* ... in which the pupil 'progresses from gross to refined control of the medium' in respect of the original sensate problem he seeks to resolve.
(School Council Working Paper 54, 1975, pp. 59–60)

If each teacher within a department is aware of sharing a reflexive approach to an integrated scheme of art, it does not matter from which point the activity originates. Reflexivity of the three elements would be the unifying framework of the whole course. The teacher's method, irrespective of his particular attitude, must operate within the framework. The basic tactics of the teaching–learning strategy can be as diverse as anyone requires as long as the strategy operates

within some sort of negotiated form. Even the selection of the problem by the teacher can create an inhibiting constraint upon the pupil. For this reason the sooner the pupil is able to identify his own problem, the sooner will he be truly independent. The teacher's function is to encourage the pupil to be independent in his selection of problems and solutions, and whilst the pupil is working making sure that he is moving flexibly and reflexively. This will entail presenting him with alternative avenues, artificial constraints, overviews of progress to date, and encouragement through identification of potentials. In order to stimulate and extend activities, it may be necessary to introduce new skills, materials and techniques. At other times, to maintain progress, it will be necessary to divert pupils into alternative areas of experience. Sometimes ideas will need to be revitalized by discussion, argument or even direct conflict. This is the centre of the teacher's function, where he operates as a professional educator and artist. Too often this is obscured by his need to be technician, child-minder, registrar, school cleaner and proctor. All peripheral functions cannot be removed, but we should try to minimize their importance and concentrate on essential issues.

In the first and second years of secondary school, with the teachers working as a cohesive team and the pupils working in relatively large groups, the degree of flexibility will be limited but the teacher must work towards a time when a one-to-one relation-ship is possible. If the process is too fast, the pupil will still be teacher reliant and consequently frustrated in an open system; too slow, and the pupil will be frustrated by the inhibitions of the teacher-based system. Pacing and sequence are important. The lock-step of the group must be broken by freeing individuals from its constraints, as and when they indicate their readiness. This does not mean that once they are free and able to work by themselves, that they must. Group activities should be as normal as individual work, but the group should be independent and self-motivating by the third year for the majority of pupils. (See also Chapter 4, 'Starting points'.)

PROCESS OR ARTEFACT?

Any discussion about the procedures for art education must con-sider whether the emphasis is to be upon the continuous process of exploring and discovering new insights about self, society and art, *or*

whether it is to be centred upon the production of works of art which satisfy the individual as an expression of impulses, feelings and ideas in an appropriate aesthetic form. The debate can never be resolved because of the differences in values, attitudes and judgements to be found in any group of art teachers. Any decision made will have considerable bearing upon the procedures used. The attitude towards the handling of media and the choice between a problematic or solution-centred approach, will be crucially affected by whether the emphasis is on process or artefact. The two approaches are difficult to reconcile as they derive from differing cultural, social and personal attitudes. (See Chapter 8, 'Individual, Social, and Cultural Emphasis'.)

Decisions made by art teachers in this area are probably more important in determining overall aims and related objectives than any other single factor. Teacher will discover in discussion that it is the personal attitude of those involved towards process and artefact which is crucial in any final statement about aims.

## The criteria of art education

The problem with criteria in the arts is that they are not based on norms or standards. If art is a way of knowing, thinking and understanding it can only be known, thought and understood within the range of concepts, procedures and criteria which are art.

Elliot Eisner comments:

> Some people say that if a teacher does not have objectives, he does not have any criteria for judging a student's development of his work. I think this objection results from confusing criteria with objectives. Critics of art, literature, music, dance and poetry do not assign painters, writers, composers, dancers and poets behavioural objectives. Yet critics lose no time evaluating their work. One does not have to have an objective in order to evaluate or appraise the quality of experience or of art. One can and does look backwards, as it were, not to see if artists realized specific objectives that were assigned in advance, but rather to determine what they did achieve. Indeed, art at its best enables both critics and artists to expand their criteria regarding the nature and quality of art. Some of the greatest art forms man has produced have been iconoclastic. They fit none of the criteria that existed at the time they were created.
>
> (Eisner, 1973)

Dewey also remarks on the relationship of criteria to standards:

If there are no standards for works of art and hence none for criticism (in the sense in which there are standards of measurement), there are nevertheless criteria in judgement, so that criticism does not fall in the field of mere impressionism. The discussion of form in relation to matter, of the meaning of medium in art, of the nature of the expressive object, has been an attempt on the part of the writer to discover some of these criteria. But such criteria are not rules or prescriptions. They are the result of an endeavour to find out what a work of art is as an experience; the kind of experience which constitutes it.

(Dewey, 1958)

Bob Witkin says that

progress is measured in terms of the complexity of the sensate problems he can handle. The elaboration of the world of sensate experience for the pupil constitutes his personal development in the most intimate sense possible.

(Witkin, 1974, p. 49)

The arranging of the different elements of the course into a sequence will derive from and be dependant upon the teacher's ability to evaluate the pupil's capacity to deal with 'complexities of sensate experience'. The evaluation of this aspect should be the determining factor in art education, rather than substituting for this an assessment of cognitive skills.

EVALUATION

For an art course to be successful it must have some basis for evaluation, both by the pupil himself and by the teacher, in order to moderate change, renewal and wastage. Apart from the requirements of external examinations, with which many departments will still wish to be involved, there need be no final evaluation. Progress can be evaluated by the pupil and by the teacher formatively, i.e. on the basis of continued observation, by identifying favourable and unfavourable outcomes, noticing opportunities for development and extension, and examining activities in terms of their 'cost effectiveness'.

Evidence for evaluation can be found by the teacher through contact with the work in progress and the processes of the work. The two aspects are totally interrelated. The processes adopted by the pupil when searching for expressive form are as important as the resulting form or artefact. The artefact should not be viewed in

isolation by the teacher. For the pupil the end and the means are inseparable and any evaluation should take account of this.

The finished product is useful evidence in any evaluation, particularly if it is viewed in the context of a sequence of associated sketches, models or writing, which give some idea of the scope of the activity. We have now moved from the finished product to the range of practical activities, and the teacher would often have to look far beyond these and consider the background, asides, discussions, false trails, conflicts and frustrations that punctuated the activity. The most obvious evidence would be found in changes in the pupil's attitudes as he moves through various problems. Does he use a wide range of resources as a basis for his problem solving? Does he continually consider alternatives or get stuck with one solution? Does he consider problems in visual and tactile terms or does he translate from one form to another? Does he value ingenuity and uniqueness? Does he give evidence of being visually aware and discriminating? Is he willing to take a leap into the unknown and risk failure as the price of a fresh approach? Is his perception of the world sharper?

In answering all these questions, the evaluation is usually composed of seemingly small items of evidence gleaned from continual interaction between the pupil, resources, artefact, technician, other pupils, and the teacher. If the evidence indicates that the outcomes are less favourable than hoped for, then the pupil or the teacher must look at his strategies to see if an alternative way can be formulated to improve the outcomes. Subjective evaluation is full of pitfalls but it is the tricky path we have to take to avoid destroying our concept of art education.

Any form of external evaluation tends to prescribe the activity to be evaluated. In some cases, the evaluation process is defined before the activity is described. In art evaluation there is no external standard against which the process or artefact can be assessed. Some people believe that artistic standards exist, although they have never been able to formulate them effectively. It is essential that we, as art teachers, approach formative and summative evaluation carefully and avoid formulae and strategies which others, from different disciplines, insist that we adopt so that they can achieve a 'unified standard'. I intend to go the whole way and propose a scheme of self-evaluation. This method reinforces the relationship between the child and his work; it places the teacher outside the evaluative

process and gives him greater credence in the child's eyes as an adviser, because the advice is open and not seen as a means to the teacher's end. If the process of self-evaluation is recorded on a work progress sheet (a suggested format is shown on p. 133), the pupil is always in touch with his continuing activity and is more able to understand the meaning of what he is doing.

The pupil has to be introduced to, and given confidence in, this method of evaluation. In the early stages there is an inevitable tendency for the pupil to over- or undervalue his own work. Once recognized by the teacher this can be rectified by discussion. Very quickly the pupil realizes that the only person he is cheating is himself, and he discovers that he wants an effective record to follow, not something that does not relate to his activity. It would seem best to allow revision of marks in the first year as a useful way of moderating the pupils' own standards and as a means of giving greater validity to the scheme. By the third year their marks and comments should be a valid basis for understanding their own work and communicating with others about their ideas. I am quite confident that if pupils were able to assess their own CSE work within the group (i.e. group moderated self-assessment), there would be little more debate than there is at present between teacher and moderator.

All evaluation of art work is subjective. The subjective bias of the creator is, in my opinion, preferable to the objective or subjective evaluation of an external examiner. This does not, however, exclude the teacher from evaluating the work of the pupil with reference to educational objectives, and there has to be a continuous formative evaluation by the teacher of the concepts, procedures and criteria being used in the course of teaching. The method I have outlined helps to avoid the creation of prescriptive formulae and their dangerous consequences: the teacher has to negotiate the evaluation and educational objectives *with* the pupils; the pupils evaluate their work against their own implied or explicit objectives. Evaluation thus becomes an inseparable part of the process of art education and not an external *post facto* exercise.

The function of criteria in art is to disclose its meaning and illuminate its answers. These criteria are not revealed by specification or by the technical use of materials but only by the observation of art in action. An art teacher is entitled to approach the art work of his pupils with declared attitudes, but he cannot apply these without

witnessing art in action. The object of critical evaluation should be to disclose the meaning of the work of art rather than to assess its worth. An art teacher's real ability is revealed in his capacity to develop sensitive criteria appropriate to the concepts, procedures, and products of his pupils' activities.

# 7 Art education in operation

## THE RATIONALES FOR ART EDUCATION

I think that art and craft education can be divided into six main identifiable strategies supported by distinct rationales, all of which share common aims but attempt to achieve them in different ways. I will identify each rationale in its simplest form but I doubt whether any would be found operating in their purest forms. Most art departments have a more complex system containing aspects of some, most, or all of the rationales described here. In Figure 7.1 below I have related the various rationales to the three facets of art set out in previous figures. Most supporters for a particular rationale would claim a wider scope than the area allocated. My intention is to locate the main emphasis of a particular rationale as a means of clarifying the issue.

In defining each rationale I will use as far as possible descriptions written by people who identify with that particular attitude. The exception of this is the use of Erik Forrest's definitions. Where I am unable to find an appropriate definition from published works I will endeavour to define it on the basis of my experience of people who work in this way.

> I believe that what is wrong with our educational system is precisely our habit of establishing separate territories and inviolable frontiers; and the system I propose in the following pages has for its only object the integration of all biologically useful faculties in a single organic activity.
>
> (Herbert Read, 1944, p. 204)

## THE CONCEPTUAL OR ART-BASED RATIONALE

The emphasis in teaching will be on stimulating the child to explore his

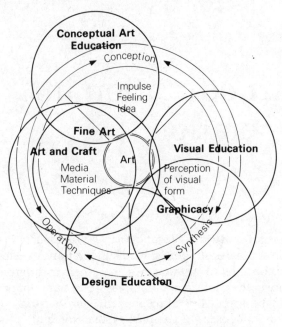

**Fig. 7.1** The rationales of art education.

emotions and feelings within a set of artistic conventions which, as far as possible, he chooses for himself. There will be some attention given to the learning of skills and techniques within particular media areas but this will be seen as subordinate to the expression of specific emotional states, and the main task of the teacher will be to stimulate awareness of the emotional qualities in the pupil's experience and to encourage the externalization of these in the chosen medium. The teacher is likely to see his task in terms of attending to, supporting, providing the right environmental conditions, and to see the child's development in art as an unfolding of latent potential, a releasing of innate abilities.

(Forrest, 1969)

The emphasis is on examining the way in which children can be encouraged to use any combination communicative methods to express facts, ideas or responses – through the use of words, sounds, symbols, graphic and ready-made images, physical gestures and movement, projected images. This has, in many projects, led to some very exciting work simply by making children aware of the range of expression that is at their disposal when the formal

categories of writing, talking, image-making, sound-making are combined, as they are in the communication media that probably affect them most – television and films.

The main problem in the expressive arts – that of finding a genuine working relationship between the different branches – is being overcome most effectively where teachers are realizing that it needs to be based on shared concepts which link them yet allow room for individual development, rather than on a common theme, whether literary or abstract, which may provide a semantic link but which may inhibit one or other of the arts.

This is probably the hardest rationale upon which to build a strategy; or conversely many strategies exist which have the above as their rationale, but in operation the constraints of the pupil, classroom and school environment militate against its successful implementation.

This rationale emphasizes more than the others the development and realization of the personal reality, albeit within a social reality. In this the pupil's ideas, impulses and feelings are paramount and he is encouraged to relate to the community through his understanding of his uniqueness in terms of expression. In its most free form it is almost intolerable to the school system as its emphasis on 'self' and 'questioning' often put pupil and teacher at cross purposes in institutions which emphasize social reality and acceptance of norms.

This rationale will often be found operating in departments which have a practical affinity with the other 'expressive' arts – drama, movement, language and music. There is often a considerable congruency between the stated aims of drama and an art department whose work is centred around this rationale.

## THE DESIGN EDUCATION RATIONALE

Typically an art programme based on the concept of design education will have students and pupils make simple researches into marketing and design problems. It will involve them in analysis of problems of function and the ways in which solutions for these will be found. At its best it will stress and illuminate the inter-relationship of the visual and functional aspects of artifacts within a comprehensive study of the twentieth century environment. Pupils may be engaged in making graphic designs, product designs and experiments in visual perception related to attention and communication. Objectives will include the development of critical

abilities in relation to the hardware with which we are surrounded and to the mass media, understanding of the necessary compromises in any design solution, skill in different methods of problem solving.

(Forrest, 1969)

This rationale has tended to dominate much recent discussion about the function of art education. It is an attractive rationale for administrators, head teachers and 'integrators' because its objectives appear to be related to socially worthwhile outcomes, whilst allowing the pupil the opportunity for individuality in problem-solving and creative work. The strength of supporting argument can be felt in the following comments made by people who place considerable emphasis on this rationale.

Perhaps the most cogent summary of the aims of design education was produced by Tom Hudson:

> Our education should create an environment where an individual can discover something of himself, his aptitudes, the relevance of his ideas and of other people's ideas, that is of collective experience devoid of mystique and mythology. He must use whatever tools and processes are necessary to himself as an individual and to society, that is, experiment, analysis and development, but of necessity in an enquiring and personal way and not by merely reproducing past forms and successes.

(Hudson, 1968)

Philip Roberts, Head of the Design Department at Oadby Manor High School, has enlarged on this and related it to what can be done in school:

> It is not the intention that 'Design' should be an additional subject on the timetable; it is rather that through a network of multi-disciplinary (if relevant) activities our pupils may gain a better understanding of themselves and their surroundings. We feel that the language of design provides the means of discussing this: that it can be a means of articulation between specialists of varying disciplines: and that it can provide a vehicle for interdisciplinary work. It can be the element that draws together the social, technical, economic and aesthetic factors inherent in beginning to understand contemporary society and its culture.

Peter Green, one of the main exponents of design education as a fundamental part of art education, states:

> In simple terms, I think attitudes in design education have developed to realise that:
>
> (a) Design is not just about visual style, but is about the total all-

embracing process of decision-making that defines the form impact, appearance and effect of man's solutions to human needs.

(b) That function is not just structural and physical. The visual function of an object, and of our surroundings, meets a need in exactly the same way that physical needs are met. Realising that visual appearances do not just happen but perform a function and meet precise requirements is a core concept for art/design education. It removes drawing from a vague field limited only to talent and gives visual form a clear critical and communicative role in understanding the reasons why our world looks the way it does.

To understand the forces forming our total world requires the development of new ways of critical analysis. Such study looks at how decisions are made and gives experience in identifying problems and evaluating solutions, in fact understanding the role of the designer/decision maker.

(Green, 1974)

The design education rationale is usually supported in rational terms. The following passage is interesting in its fervour and damnation of alternative rationales.

Integration involves dilution and fragmentation of our disciplines. Co-operation between areas based on sound disciplines produces the most valuable multi-media experiences.

The dangers of dilution and fragmentation arise from two sources, the integration epidemic and misleading pronouncements as to what art and art education are primarily about. 'Art is primarily about communication', asserts one pundit. 'Art education is primarily mental growth' – 'Art education is best considered as aesthetic education' – 'Art education is visual education'. Then a mental somersault, 'Art education is not confined to the visual arts'. The truth is that art and art education are not primarily about any of these things. Art and art education are primarily about creation and creativity. 'What blindness has overtaken us', writes Professor Kuiper, 'that prevents us from seeing that the urge to create, to bring forth the new from the old, is at the foundation of the universe.' Jacob Bronowski recently commented that animals leave evidence of what they were: man leaves what he has created. All work concerned with art, and the designing and producing of artefacts, should be planned in a co-ordinated sequential programme. This includes wood and metal. 'The Unity of Art' was the cry of the Arts and Crafts movement, taken up by Gropins. The Bauhaus approach, like Christianity, has not been found wanting, but hardly been tried.

But why should art education be based on areas where artefacts are produced? Why not have creative studies departments formed from all manner of subjects? The answer is simple. Once we separate art from the

artefact, art means many things, hence nothing in the collective sense. How then can we argue about art education being sequential, meaningful, etc.?

An even stronger argument against forming a department of expressive and creative studies, as distinct from other departments, is that such a division suggests that the other departments are not involved with creative work, whereas creative work should be the basis of all subjects.

(McDonald, 1944)

This statement clearly emphasizes the major dichotomy that exists in art education. It depends upon who defines 'creativity', 'design', 'process', and 'artefact'. I have decided to take creativity out of the set of rationales as I feel that it is common to all art activity (see Chapter 8). But difficulties will still occur when the 'integrated arts' teacher is asked by the 'design education' teacher for a precise definition of the term.

I have quoted passages at some length here because this is probably the most clearly articulated of all of the six rationales and the one most readily adopted at the present time by administrators because of its logistic convenience.

### THE VISUAL EDUCATION RATIONALE

This rationale is strongly related to design education, but it is not so prescribed by functionalism.

A visual education programme will sub-divide into exercises and activities exploring discreet visual qualities. These will be dealt with first separately and then in various combinations. These qualities will be seen as having unique characteristics not related to their possible function as symbols, or signs, or as illustrative of verbal concepts. There will be exercises in colour, tone texture, in line, plane and column. ... There is likely to be great stress on the universal significance and importance of mathematically based organisation and on the underlying usefulness of this in all areas of art and design experience and production.

(Forrest, 1969)

A supporter of this rationale would maintain that to know and understand all does not make one an artist, but that the artist needs to be visually sensitive. He would further assert that art is not teachable and that it is therefore best not to tackle objectives concerned with behaviour where the basis for judgement is so intangible, but to concentrate on those aspects where some basis for

judgement exists. This creation of a visual language for expression and communication based upon observation of the environment is clearly set out by Bob Clement.

At an objective level this means an increasing emphasis upon the straight forward visual analysis of the natural and man made world and observation of those many elements that form it through the exploration of the properties of space, colour, structure, form, symbols and images etc. If such exploration is made in relation to those of other means of externalising experiences available in other areas of the curriculum, through working relationships with environmental studies, creative writing, mathematics etc. This can help to emphasise the value of visual communication as a natural and useful means by which to respond to the world rather than the means by which a chosen few can make fine art images and artefacts.

The examination and analysis of these complex elements gives children experience in that process of abstracting from generalities in order to arrive at the understanding of specific relationships. Through this analysis they can begin to understand that the significance of the whole is dependant upon an understanding of the component parts.

(Clement, 1975)

At its most successful, art, more than any other subjects, presents the possibility of a complete synthesis of experience, involving the integration of perceiving, thinking and feeling. And if art is to be seen as central to the curriculum it is these educational functions that should be the criteria around which the work of art departments is planned and evaluated, rather than those more peripheral functions traditionally associated with art.

The strongest support for the use of this visual rationale in art education came from the exponents of the 'Basic Design' method, Victor Pasmore, Harry Thurbron, Tom Hudson and Richard Hamilton.

The development of new foundations in art training, on a scientific basis suitable for introduction into schools of art and technology is a necessary step following upon the decline of the classical academics and the new developments in modern art and technique. What is required, however, is not merely extra marginal studies added to the existing academic training, but a new foundation to the art students' course altogether.

In attempting to formulate a new scientific foundation to study and practice, it is necessary to bear in mind that something more is required than a ready-made repetitive course of abstract exercises. It is essential that any course of studies which is devised is one that is capable of

extension and development. . . . An objective theme or problem is set and the student is asked to analyse or develop it, either within given limitations or freely in such a way as to present other problems. Exercises should be developed both in the abstract and 'from nature'. But the nature which is analysed is not confined to the finite phenomenon of classical naturalism; it is extended to the wider sphere of relative processes . . .

. . . such a course therefore must provide not only the means for intuitive development, but also the objective foundations for analytical research.

(Pasmore, 1959)

This rationale tends, although not exclusively, to be related to the problems of graphic design and constructionist sculpture. It is very rarely found in its purest form but it is one of the main undercurrents of all other rationales. Its objective approach to art education is both liked and disliked by art teachers. Too much creates sterility, too little risks chaos.

## THE FINE ART RATIONALE

Art teachers using this rationale see their subject in cultural terms as enlightening and enriching. Art is felt to be a means of filling leisure time positively, either through personal artistic expression, or appreciation of the works of others. Through this activity a person is able to lead a richer life. Nowadays people enjoy an increasing amount of leisure time and it is necessary for schools to encourage pupils to use their leisure to enhance the quality of life in general, and to counteract the possible drabness of existence during 'non-leisure' hours. It follows that the best person to teach art is an artist, and his role would be to pass on his skills and knowledge to others so that they may develop their powers of self-expression.

Typically a programme of Fine Art Education will consist of activities in a range of media used by artists in the past and at the present time. The children will produce paintings and sculptures, works in clay which are other than 'useful pots to put things in', will make collages and montages, and constructions with fabric and metals and plastics . . . unrelated to any functional purpose.

(Forrest, 1969)

There is a secondary rationale contained within and associated with the fine art rationale, namely the cultured critic benefiting from

his sensitivity and appreciation of the works of others. Brian Allison suggests:

> that a more appropriate model for art education is not the 'Artist' but one which has the sensitively responding and discriminating consumer primarily, alternatively or at least equally, as its base.
>
> (Allison, 1974)

Elsewhere he says

> As a means of clarifying a positive role at all levels, I have suggested that the analytical, critical, historical and cultural domains should have an interactive and equal role with that of the presently pervasive expressive/practical domain and that, whilst emphasis might change with circumstance, situation and individual involved, all these elements should be attended to within any one learning situation. Within this context, I have suggested that the critic, historian, autonomically discriminating consumer is a more realistic and appropriate model for art education than that of the artist.
>
> (Allison, 1973)

This rationale tends to be more concerned with the transmission of value judgements than the fostering of awareness of individual values. Its supporters tend to justify it in social, cultural and 'leisure' terms.

> As one of the humanities, the visual arts illuminate significant and unique aspects of human experience; for this very reason they provide an essential element of basic education. . . . The 'agent' of art education has a double impact because art educators prepare the public and they prepare the professionals who will be the future producers of art. It is posited that we should not aim at breeding passive art consumers . . . but instead at multiplying the number of active and critical participants in the adventure of art.
>
> (Chalmers, 1974)

This rationale is an attempt to counteract 'cultural deprivation', in other words the suggestion that pupils are estranged from the wider cultural concerns of their society, or are, at other times, lacking in a 'proper' appreciation of aesthetic values.

> The fact that civilization endures and culture continues – and sometimes advances – is evidence that human hopes and purposes find a basis and support in nature. As the developing growth of an individual from

embryo to maturity is the result of interaction of organism with surround-
ings, so culture is the product of the prolonged and cumulative interac-
tion with environment. The depth of the responses stirred by works of art
shows their continuity with the operation of this enduring experience.
(Dewey, 1958)

Art is seen here as having an essential role which is diminished by
too great a concern with individual sensory training. There is a
concern for quality based upon traditional standards. The basic
hypothesis is that the child acquires some perceptual skills through
interaction with culture, and that the qualitative aesthetic approach
develops better artistic judgement and discrimination.

## THE ART AND CRAFT RATIONALE

The art and craft rationale could encompass design education, visual
education, and art education, but it has such a distinct style in
operation that it deserves its own heading. It existed almost nation-
wide in art departments in the late 1950s and early 1960s. It involves
the selection of certain crafts or activities, e.g. painting, lino print-
ing, pottery, fabric printing, wood carving, typography, weaving,
and these become the areas within which the other elements are
taught. In painting, initial exercises using the various materials and
different elements of visual form lead to the use of these in the
making of a painting which expresses the individual's response to a
subject or project usually selected as appropriate by the teacher. In
pottery, simple, manipulative exercises lead to exploration of visual
form which then allows the pupil to integrate the elements into a
simple pot or figurine.

This rationale aims at the creation of stylish, tasteful objects,
preferably functional but failing this, at least decorative. The
emphasis is on the manipulation of materials, media and tech-
niques. The arguments behind this rationale are similar to those
behind the fine art rationale but here the emphasis is less on high
culture and more on the visual environment. Ernest Goodman
certainly makes little distinction between the fine art and the
art/craft rationales.

Another view which needs examination is that art education is concerned
with two things. The production of pleasing artefacts, preferably of a
permanent or semi-permanent nature, produced to enhance the
environment, much as a flower-bed or patterned wallpaper does and art

appreciation, in the sense which I have just outlined, which serves to strengthen elitist concepts and traditional values.

(Goodman, 1973)

Like the design rationale, the art and craft rationale wishes to improve the quality of the environment but in this case more emphasis is placed on sensitivity and the aesthetic use of materials to enrich life and society.

This rationale is not articulated clearly in journals or books on art education. It can be defined most easily by analysis and synthesis of the ideas and practices of art teachers in a large number of secondary schools. It is probably the most popular of all the rationales for both head teachers and art teachers, and evidence of its existence can be found in the continual references to it in articles suggesting better alternatives! A strong justification for this rationale is also to be found in a survey carried out for the Department of Education and Science (Education Survey 11, 1971).

The process of understanding and evaluating begins with a certain material substance and leads on to a created object. The making of an object demands many decisions and is therefore an excellent training in independent judgement. That pupils should be treated as people who have the capacity to form a right judgement was recognized in the Newsom report (1963). The wise teacher will seek to extend the lessons learnt through making objects into wider fields, so that pupils will ultimately be able to give a pleasing character to their environment. Certainly the general quality of our environment indicates the need for greater emphasis on this aspect of art education.

Henry Pluckrose writes:

Man's progress towards civilization has been marked by his ability to discipline materials, to fashion clay, metal and wood, to spin, to weave, to carve, to construct, to build. In an age when individuality is being continually undermined by mass production ('soft-sell', 'built-in obsolescence'), all our children, born into a technological society, need to have some awareness of the basic processes of mankind, if they are to live fully.

(Pluckrose, 1972)

Herbert Read comments in the same vein:

The crafts could, more than any other form of education transform our social environment. As an instinctive revolt against the shoddy products

of our factories they could immediately bring into the home an undercurrent of good taste, in furnishings, in clothing, in utensils. In the long run they could transform the factories themselves, by creating a taste to which, if only for economic reasons, the producers would have to conform. This is placing a heavy burden of social responsibility on the schools, and on the art teacher in particular. But the necessary revolution can begin nowhere else; in tender human shoots, not yet distorted in mind and body by a world grown ugly.

(Read, 1952)

THE GRAPHICACY RATIONALE

This rationale emphasizes the need to create an individual capable of communicating information and ideas by visual methods independent of written language. There is a link with the basic elements contained in the visual education rationale, but here the emphasis is on the effective use of photography, diagrams, drawings, signs, symbols, illustrations, maps, models, posters, films, and any other visual form which can be manipulated in order to communicate ideas or information. This rationale thus emphasizes the role of man as a communicating animal and tries to extend the means which are available to him. At the 1972 York Conference on 'Visual Education' the development of this aspect of education was discussed and proposals were made for its continued study. In an introduction to the conference Professor W. G. N. Balchin said:

Graphicacy was defined as the educated counterpart of the inherent visual-spatial ability that we all possess and was thought of as being analogous to literacy, numeracy and articulateness as a means of communication. Graphicacy is fundamentally the art of communicating spatial information that cannot be conveyed by verbal or numerical means, e.g. the plan of a town, the pattern of a road or rail network, a picture of a distant place – in fact, the whole field of cartography, computer-graphics, photography, the graphic arts and much of geography itself.

The demand for this form of education comes from people who work in areas which are located outside the area generally accepted as art but who need the kind of skills generated by the graphicacy rationale in order to facilitate study in their particular field. Reasonably they see the art teacher as the most appropriate person to develop these skills within children. Later in the same introduction Professor Balchin defines the area of content for graphicacy quite precisely.

In a very condensed form the content might embrace the following concepts and skills: appreciation of direction and distance; appreciation of size, shape and area; linear and angular measurement; space relations and map forms; appreciation of scale; conventional signs; colour distinctions, pattern recognition; mathematical graphs and their interpretation; use of co-ordinates; map projection and art projection; perspective in field sketching and photography; perspective in area reproduction; map making and map interpretation; networks and distributions; ground and air photo interpretation; photogrammetry; colour, radar and infra-red photography; computer graphics; remote sensing devices.

(Balchin, 1972)

A lot of this would fall within the area of the visual education rationale but as the objectives are highly cognitive and little consideration is given to the development of a visual language for more personal reasons, I think that it must be treated as a completely separate rationale. It obviously appeals to teachers of other disciplines who feel that the work of the art department is of little value to them in their subject areas. Equally it appeals to art teachers who wish to give art some positive social purpose and emphasize its general practical value.

Robert Brazil said at the York Conference:

In the first place the young child uses a visual means of notation quite naturally to relate himself to his environment and the visual thoughts that his situation stimulates. Drawing for him has a value as a way of recording shape, scale and space, the work that he produces has meaning for him and for others in explaining both the detail and the wholeness of an event in the terms of the medium that he uses. At a later stage, however, a division of attitude does occur in older children as well as in those who teach them. A distinction is made in the drawing which is about an imaginative adventure and the drawing which is a statement of fact. In the first case the picture is thought of as an art object and in the second case the plan, the graph and similar means of expressing information are seen to belong exclusively to other subject disciplines.

But I suggest this division is not as clear cut as that. Where, for instance, would you put a drawing of a plant that says something very factual about the way that this natural object is built and the way that it works as an efficient structure? Perhaps the high degree of understanding that has been recorded in this drawing makes it, if the information is really well-stated, a valuable object in its own right, and it is art as well as information formation.

The child, at this later stage, still needs, and must have, an outlet for

personal expression, but with his greater capability for abstract thought he finds that his natural development is not now met by coherent response by teachers within the syllabus.

(Brazil, 1972)

Here art education becomes the means of achieving the skills required to become an artist or topographer and the emphasis is firmly placed on this aspect.

# 8 General considerations

It is very easy to assume that, in defining a course strategy, one simply starts with the general aims related to the concepts, procedures, and criteria of art. However, there are areas where differing attitudes may alter the way the aims are formulated. Some of these have already been discussed in Chapter 6 under 'Process or Artefact?'. There are other issues capable of dividing art teachers into opposing camps. In this chapter some of these will be introduced to indicate the range of possibilities open to a group of teachers. Some extreme positions are unreconcilable but there is considerable opportunity for agreement if everyone is conscious of an area of common ground from which each teacher may then be able to diverge.

As has been stated previously, the intention of this book is not to suggest any particular strategy for art education. In spite of this, the reader may be aware of a tendency to view the subject as creative and personal, as opposed to systematized, social, and cognitive. It is hoped that the reader does not feel that this detracts from the book's aim – to provide a framework for the discussion and negotiation of all ideas. It is my profound conviction that many of the different approaches being used at present are achieving excellent results and these will only be improved by co-operation within school between teacher and pupil. This book though, seeks to increase understanding between different centres of excellence and this can only come about through increased understanding of the crucial factors which determine what art education is about.

At present there are few means available for the art teacher to exchange his practical and theoretical teaching wisdom with others.

There are no British journals or periodicals which create a vehicle for open discussion about research and practice in the field of art education. Until such a publication is available (and at the time of writing, August 1978, things are looking more hopeful) most discussion must be in groups, seminars, and lectures. In this context a basic framework is essential to enable the main issues in art education to be considered.

## Creativity

A large majority of art teachers consider creativity to be an important element of art education, but it is extremely difficult to arrive at an acceptable working definition of this term. It is probably one of the most misused words in the whole of education. Creativity is an element common to most teaching but it is expressed and sought in a variety of different ways. Lowenfeld said '. . . there is a strong thread of creativeness which links all fields of human endeavour' (Lowenfeld, 1964). Perhaps too close a definition will be inhibiting, so I will restrict myself to broad outlines and hope that most teachers will find them acceptable and workable.

Guilford (1968, pp. 91–7) refers to creativity as divergent-production-abilities, namely sensitivity to problems, fluency, novelty, flexibility, organization and elaboration, redefinition, and evaluation. This scheme is useful because although it tends to emphasize process over artefact there is usually a by-product of a process even if this does not constitute a finished artefact.

Creativity according to Bruner (1966, a, b), must be effective – in other words, it must be recognized in the productive outcome of some process.

This is *where* creativity is to be found. This is not to say that movement or drama are not creative. The difference is that 'product' in this context is a unity expressed through a continuum of events. This is taking a 'soft' view of production. It *can* be found in end products (this is the hard view of production) but it can also be identified in the by-products of processes.

Having defined where creativity is located we must now look at what we are locating. Poincaré (in Field, 1970, p. 33) describes sequential stages of creativity as identification; clarification; uncertainty – maturity; insight – discovery; rationalization – verification. Peter McKellar (1967) suggests preparation; incubation; illumination; verification; assimilation. Probably Lowenfeld (1969) is most

useful in our present context. His stages are similar to those set out by Guilford but they are more extensive and related directly to art as an activity.

*Lowenfeld's stages of creativity*

1 *Sensitivity* to problems, experienced through the senses.

2 *Fluency* Experimenting with alternatives; adapting; playing with possibilities. Acceptance of variables and failures.

3 *Flexibility* The avoidance of preconceptions as a determining factor in finding a solution. Adjustment to changing possibilities.

4 *Originality* Uncommon responses to questions and unusual solutions to problems; independence of the ideas and solutions of others. (This is the central and crucial element.)

5 *Redefine and Rearrange* (Here Lowenfeld is linked with L. Arnaud Reid's idea of the embodiment of meaning in the form, so that ideas are embodied in a unique and individual way into the form of the solution. This stage also includes an acceptance of ambiguity.)

6 *Analysis* Abstracting from generalizations and arriving at specific relationships.

7 *Synthesis* Combining elements to form a whole.

8 *A Coherence of Organization*

Each problem will pass through these stages to the stage of creative solution irrespective of the type or magnitude of the problem. The stages move from a continuum of chaos at the lower end to a complete and harmonious organization at the upper end. The process and solution become part of the individual and enrich and enlarge his capacity to develop. This aspect is much more important than the effect of the creative process on the product.

This is a very brief look at creativity. Reference has been made to some noteworthy writers dealing with the subject. It is hoped that readers who are interested in exploring it in greater depth will use the references. Too complex a statement in the framework of this book would serve to create more problems than it solves.

## The intelligence of feeling

It would be difficult to develop strategies for art education without considering the Schools Council's *Arts and The Adolescent* project.

There are two publications directly related to this; Working Paper 54, *Arts and the Adolescent* and *The Intelligence of Feeling* by Robert Witkin (1974). The work done on this project has enabled arts teachers to identify certain common elements in their approach to teaching. In this short book it is impossible to do justice to the ideas which were developed by the project team but a short precis may serve to whet the appetite of the reader for further study of the material. It may also help to clarify the method that many teachers use intuitively.

Bob Witkin (1974) emphasizes the personal and expressive function of art and sets out a case to support this approach against the socially-culturally based argument in favour of the production of artefacts and performances. Many teachers have worked through the process of expressive behaviour in the past but have found difficulty in rationalizing their method to others. If we believe that the emotional development of children through creative self-expression is the prime concern of art education we are then concerned with what Witkin calls 'subject reflexive action'.

> A conceptual framework is presented which distinguishes between subject and object knowing, expressive and impressive action. It is based upon the notion, painstakingly developed . . . that all action is 'projection through a medium'. Expressive action is the projection of an expressive impulse through an expressive medium – such action constitutes subject knowing. Expressive action is the means by which an individual comes to know the world of his own feelings, of his own being – 'a world that exists only because he exists'. Subject knowing is subject-reflexive action: feeling impulse projected through an expressive medium yields feeling form. Subject-reflexive action is proposed as the common experiential root from which all the arts spring – subject knowing is their common goal.

> (Schools Council Working Paper 54, 1957, p. 57)

In this framework, the medium is the means through which the individual externalizes his feelings (Figure 8.1). The idea, impulse, or feeling becomes embodied in the medium through which it becomes feeling-form. The expressive impulses, feelings, and ideas must be strong enough to motivate the pupil into responding through some medium. This release through the medium enables the pupil to remain in contact reflexively with impulses, feelings, and ideas and to continue to respond through the medium. This, in turn, modifies and gives rise to further impulses, feelings, and

**Expressive behaviour**

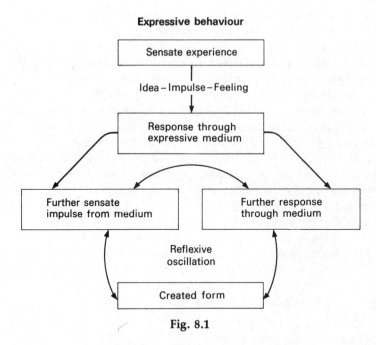

**Fig. 8.1**

ideas. The final feeling-form is achieved when there is no further interaction between expressive impulse and the expressive media. Witkin suggests three phases of the creative act.

## 1 *The setting of the sensate problem*

The teacher enters the creative process by selecting and stimulating an appropriate sensate problem – that is to say, he makes sure that there is an impulse within the child to motivate and guide his expressive action. Of the sensate problem Robert Witkin writes that quite simply all sensate disturbance whether great or small, pleasant or unpleasant, is a problem in so far as it makes demands upon us to structure our particularity.

He then proposes a tentative and intriguing model to account for the child's developing structural capacities in the realm of feelings and, in the light of that model, suggests the criteria which should determine a teacher's selection of appropriate sensate problems. The problem cannot be regarded as having been set, he says, until its structural character (contrast, dialectic or harmony for instance) is a felt experience of some intensity.

(Schools Council Working Paper 54, p. 59)

There is some difficulty in understanding the meaning of 'sensate' in the way that Witkin uses the word. It is not as narrow as 'sensory', which is concerned with experience through the senses; it also implies feelings and impulses fostered by other experiences. Sensation is the awareness of feelings. 'Sensate' derives as much from this source as from 'sensory'. 'Sensate' is not only direct sensory experience, it is also the impulses and feelings derived from an awareness of sensations arising from any source. Witkin emphasizes 'the sensate problem'. Art teachers will know that the impulse and feeling can be motivated by all manner of stimulants. Contact with the medium can be a positive starting point but the sensate problem can also arise out of experiences, situations, memories, actions, source material, and fantasies. The important thing for the art teacher is to ensure that the sensate problem 'has an expressive impulse adequate to sustain (the pupils') endeavours'.

Most teachers are aware of the problems of motivation or 'setting the sensate problem'. Witkin develops a second idea which can throw some light on how the teacher can help the pupil to maintain positive contact with the original idea.

## 2  *The making of a holding form*

The holding form encapsulates the sensate impulse for the duration of the process of resolving it. . . . It is the seed of which the full expressive form is the flower . . . The effectiveness of a holding form depends upon its complete simplicity, its minimal character. Its purpose is to encapsulate only the essential movement of the sensate impulse and to hold that movement in consciousness for the duration of the expressive act . . . It is the essential gestalt of the disturbance that is held in the holding form.

(R. Witkin, 1974, p. 180–81)

This idea is more easily experienced than described, and even when understood it requires considerable perception on the part of the teacher and the ability to understand and respond on the part of the pupil. In spite of this, it is an idea worthy of development. The holding form is the statement of the original idea in its most economic form. With this form 'held' the idea becomes 'encapsulated' and it is possible for the pupil to move and grow away from the original idea without drifting and losing contact. It also enables the teacher to be in contact and understand the pupil's explorations and developments. It is the focal point of the original idea from

which both the pupil and the teacher are able to make creative excursions.

### 3 *The movement through successive approximations to a resolution*

... in which the pupil 'progresses from gross to refined control of the medium' in respect of the original sensate problem he seeks to resolve.

(Schools Council Working Paper 54, 1975, p. 60)

This stage is easily understood by the art teacher. Witkin's special contribution is in the reflexive response between 'the sensate impulse for release and the expressive medium through which it is to be released'.

Movement in one creates a response in the other. Without this idea the pupil and the teacher run the risk of the pointless manipulation of the material on one side or the frustration of unexpressed ideas on the other.

Too often the two become separated, either because the pupil's task is quite beyond him, or because he is in the habit of planning in some technical way the construction of the form in isolation from the impulse that is guiding the expressive act. . . . To establish reflexive control the pupil requires to use his sensate impulse to initiate a movement of successive approximations to a resolution of that impulse.

(R. Witkin, 1974, pp. 186–7)

The reference to the work of Robert Witkin and Malcolm Ross in the *Arts and The Adolescent* project can only be dealt with in a cursory manner in this book. The importance of the Schools Council project in helping arts teachers to understand their function in school should not be underestimated, but many more teachers will have to study the material and act upon its findings before effective change can occur.

### Art as a means of development

Lowenfeld emphasizes the creative and mental growth of the child through art as his main justification for art education. He believes that it is wrong to evaluate the child's creative work by only one component of progress, particularly if this is the external aesthetic criteria of artefact design. He wants all other forms of progress to be recognized as contributing to the whole development of the child. He elaborates his ideas on emotional, intellectual, physical,

perceptual, social, aesthetic, and creative growth, maintaining that they are all interrelated. The child's needs and responses vary as he develops and matures but the teacher must work reflexively to enable the pupil to progress smoothly towards maturity.

There is no doubt of the importance of Lowenfeld's ideas expressed in his two most important books (Lowenfeld, 1965 and 1969) but to counterbalance the dominance of his thinking it would be useful to consider a passage by Elliott Eisner (1972) qualifying some of the uncritical acceptance of Lowenfeld's ideas.

Although Lowenfeld's work represents one of the most extensive efforts to classify and analyze children's art, it contains numerous assertions that lack adequate documentation. The stages that are described are not the result of empirical studies using scientific controls to insure objectivity, but insightful, even if at times dogmatic, conclusions drawn from years of experience working with children. Such an approach in the hands of a sensitive observer has much to recommend it, but it tends not to be easily corrected. Observation and insight give way to beliefs that are difficult to alter because the ground rules for alteration were not employed in the initial development of the observations. Furthermore, Lowenfeld's work does not benefit from the test that a rival hypothesis could provide. Whether creative ability is generic or specific is as yet undetermined; yet Lowenfeld implies strongly that it is generic and suggests that evidence for this has been found. Whether copying or tracing are in fact detrimental to the child's artistic growth is still not known; Lowenfeld writes, 'Never let a child copy'. These and other conclusions are problematic in character. Still there is little question that Lowenfeld's views of child art were more comprehensive and systematic than the views of others working in the field at about the same time.

A set of concepts that has been given rather special attention by Lowenfeld in his effort to account for the character of children's art are those of haptic and visual modes of perception. According to Lowenfeld, as children mature a proportion of them – about 70 per cent – orient themselves to the world in one of two ways. Those whose perceptual orientation is visual tend to see the world as spectators who view phenomena in a literal sort of way, with little affective or kinesthetic regard for the phenomena being encountered. The objective qualities of visual phenomena are the qualities they tend to perceive and, hence, the drawings and paintings they produce tend to be representational in character.

The haptic individual interacts with the world as a participant rather than as a spectator. He undergoes experience in a highly affective and kinesthetic way; hence, his drawings and paintings are not literal but emotionally exaggerated. Haptically-minded individuals tend to produce

drawings that represent the feelings they undergo as a result of perception rather than representations of their visual perception of the object's qualities.

   Lowenfeld suggests that these perceptual traits are genetically determined; hence, art teachers should not require or expect visually-minded individuals to produce haptic characteristics in their drawings, and vice versa. It should be noted that the published empirical evidence for the existence of these two types of individuals has not been validated on art tasks but on tasks requiring the production of words and the recognition of forms. Until validation occurs the existence of haptic and visual individuals should be considered interesting speculation deserving further study.

(Eisner, 1972, pp. 90–91)

## STUDYING DEVELOPMENT IN CHILDREN'S WORK

Art teachers often overlook the fact that their art rooms can become the resource centre for their own research. Many researchers would be grateful for the opportunities offered by continuous working contact with a group of pupils between the ages of 11 and 18. Some teachers feel that all research has got to be 'the result of empirical studies using scientific controls to insure objectivity' (Eisner, 1972). If the work is to be evaluated by academics then this belief is well-founded, but consideration should be given to the classification and analysis of children's activities on the basis of insight and accumulated experience. It may not enter the learned journal but it could create a firm basis upon which to develop new and more effective strategies in the classroom. It could also enliven the discussions which take place between art teachers confronted with similar problems. Art teachers should not be deterred from a close study of their work with children just because they are not trained to do so in one particular way. I am not diminishing the value of controlled research, but rather making the case for deeper enquiry by the teacher who is ideally placed, having invaluable knowledge and control of resources. The two methods can work hand in hand.

   This preamble leads to other views of child development showing how objective analytical research, when brought into contact with insightful enquiry, can enhance the value of both.

   John Willats has made an objective study of how children learn to represent three-dimensional space in drawings (1977, a and b).

In order to test the ability of children to represent three-dimensional space in a drawing, subjects of ages five to seventeen were given a real scene to draw from a fixed viewpoint. Six classes of drawing system were identified in the drawings produced and it was found that with increasing age children were able to use an increasingly complex type of system.

The classes of drawings produced in this experiment can be seen as stages in the child's attempt to solve this problem, each stage being more complex than the previous one, and requiring greater powers of abstract thought.

A child first draws objects showing their height and breadth on the paper.

**Fig. 8.2**

As he develops the need to show not only the side view but also the top, a new view is developed in which the depth of the object is shown vertically on the paper.

**Fig. 8.3**

As the child realizes that the vertical and horizontal can become confused, a new view is developed, where the depth of the object into the picture is represented by the oblique angle.

Fig. 8.4

The child soon realizes that this solution does not help in the more complex problems of space and discovers that lines above the eye generally 'go down' and below the eye 'go up'. This is the beginning of primitive perspective.

Fig. 8.5

As his view of space and form become more complex, there is a need for him to relate what he sees before him to what is drawn on the paper.

Fig. 8.6

With the more specific spacial problems found in architecture and engineering even more specialized drawing systems have to be developed.

John Willats maintains that the development of these drawing systems is not only sequential but also accumulative. The pupil (or artist) capable of using perspective will also use other systems depending upon the particular needs of the drawing problem. This opens up all sorts of possibilities for the teacher. Instead of relentlessly moving the pupil towards formal perspective, fostered by the child's wish to draw 'properly' and the teacher's sequential view of drawing, we could approach the pupil's drawing as existing within a range of possible solutions. The teacher would then be able to assist the pupil on the basis of what he is in the process of drawing instead of feeling compelled to orientate the pupil towards a universal scheme for drawing. Adolescents want to learn to draw; Witkin calls it 'the representational crisis'. But no single approach to children's artistic development is going to contain the essential truth about every child or satisfy the view of every teacher. Evidence which can be studied is produced daily in the art room and the art teacher should take the opportunity of studying the work of children from all age and ability groups. This could be done by asking every child to respond to a common subject such as 'Me and my family' or 'All around my house'. This would produce evidence of how children draw the human figure and their immediate environment.

Bob Middleton, the Warden of the Teachers' Art Centre in the London Borough of Redbridge, worked with the author ordering chronologically drawings of houses done by children between the age of 4 years 10 months and 17 years. The work was produced in schools without any direct guidance from the teacher. About 700–800 drawings were studied in terms of their developing differentiation. This covered the use of baselines, placement of doors and windows, handling of the sky and space above the house, depiction of smoke and chimneys, garages and outbuildings, street and garden furniture, handling of space in front of and behind the houses, portrayal of drainpipes, brick patterns, and wall patterns. There was no systematic categorization and the results could not be put forward as objective research but it was possible through insight, observation, and discussion to reach some general conclusions which, in their turn, became the basis for discussion and comparison with the insights and observations of others. If we look

at one aspect of the study, how children handle space in their pictures, it will be obvious how closely the work relates to John Willats' findings.

When the child has little spacial understanding he places the houses and other objects in an arbitrary relationship to one another. Later the child places the house firmly on 'the ground' and the bottom of the paper is used as a baseline.

**Fig. 8.7**

Soon the child becomes more aware of the surroundings of the house. In order to show the front garden another baseline has to be created for the house so that the garden can be put 'in front' of it.

**Fig. 8.8**

As the child's view of the environment becomes more complex he realizes that he has to develop ways of showing 'the sides' and 'behind'.

**Fig. 8.9**

This leads the child into all sorts of considerations about how to deal with space and form. The sides of the houses are 'bent round' so that they can be viewed with the front giving the impression of multiple viewpoints where each part is drawn as if viewed from the best position.

**Fig. 8.10**

The child then discovers that in order to represent roofs, bay windows, and staircases he needs to develop a more complex control of form beyond the simplicity of the oblique.

**Fig. 8.11**

This leads naturally to the development of the rules of visual perspective seen in some of the work of adolescent children.

There are many possibilities in this sort of teacher-based study, but too often the teachers are put off by demands from academics to justify their experience and insight by methods unrelated to the way they normally operate. They know that their knowledge of art is insightful and not based upon 'empirical studies using scientific controls' but they are often reluctant to turn this insight into a deeper study of their own and their pupils' work in art education. When the conclusions of the work done by Bob Middleton and Maurice Barrett was compared with the research done by John Willats not only were important parallels recognized but both sides were able to benefit from the work of the other.

## THE STAGES OF CHILDREN'S DEVELOPMENT

It is impossible to try to construct a syllabus or design a course for children without viewing the activities in some sort of progressive sequence. It is probably necessary for this to be seen against the developing characteristics of the pupil. Most art teachers are aware of the differences in the maturity of their pupils. This is usually related to the age range of the group but certain pupils will be working in a more sophisticated manner than their class mates, others will still be working with very simple forms and techniques.

Even if one accepts the 'developmental' approach, there are alternative approaches and views of growth of children in art. Perhaps it would be best to start with Elliott Eisner who, in challenging Lowenfeld's *Creative and Mental Growth* (1969) also calls into question the assumptions of developmental educational psychology.

> ... it should not be assumed that it is possible, once and for all, to characterize children with respect to their location on either a developmental or cultural continuum, because both the developmental patterns and the cultural conditions change over time. . . . Given these changes in culture, developmental patterns, with respect to readiness, also alter; thus, what might have been valid data on the status of a group five or ten years ago cannot necessarily be considered valid data today.
>
> (Eisner, 1972)

Eisner confuses the development issue by introducing cultural and personality influences. It would be wrong to hold fast to any one sequence of development to be found in the work of all children. As

new phenomena enter the world of the child new forms will be developed to express them. The helicopter is a good example. The schematic form for this tends to enter children's drawing at about the same time as aeroplanes, cars, bicycles, road menders, that is at about the age of 7 to 9 years. Some children will never include helicopters in their work, others will be dealing with them at the age of 5 and some will not be concerned with them until early adolescence. In spite of these variations, it is possible to discern a pattern if a sufficient volume of work is studied. The important point to consider is the similarity of form adopted by children of comparable age and the increasing complexity of the form as children mature. A 6-year-old son of a helicopter pilot, who has flown with his father, will not have the same image as another child of the same age who has only seen a helicopter on one occasion at some distance.

Equally, the level of perception and drawing experience can vary considerably. To take an extreme example, pupils of 16 years of age, severely educationally sub-normal, could produce work having more in common with 'normal' 5-year-old children. The level of development cannot be tied absolutely to age or intellectual ability. The paramount factor in studying the work of any pupil is the pupil himself. The work cannot be assessed against a norm for there is no such thing as 'the normal child'. Each individual will define his own route, influenced by cultural, environmental and personal experience.

Whilst accepting that art is fundamentally concerned with the development of the individual, it would be difficult for the teacher to ignore the evidence of parallel patterns of growth experienced by pupils in their progressive development from stage to stage. To refer back to the extreme case of the educationally sub-normal pupil of 16, an awareness of the range of development present in a class of five-year-olds could be of some value to the teacher in trying to assist the 16-year-old pupil in developing his best mode of expression. This is not to suggest that teachers should use their knowledge of the stages of development to teach in a set manner prescribed by their view of the norm. The range of development merely becomes the framework within which the teacher is able to view the work of all pupils. Ideally, on a one-to-one basis, where the teacher has been in contact with the pupil for a number of years, it should be possible to ignore parallel patterns of development and rely exclusively on the evidence of the individual child. But with thirty pupils arriving

at the art room once a week for about one and a half hours and this happening fifteen times a week for groups between the ages of 11 and 18 it would seem necessary to adopt some framework for viewing the pupils' work in order on the one hand to create a viable syllabus for the group and on the other to approach the work of the individual child positively.

As the object of this book is to study a range of approaches to art teaching, where child development is concerned different approaches to the subject will be introduced so that teachers may decide for themselves which one comes nearest to their own view of children. In the end the suggestions given here may be rejected or amalgamated and it is hoped that the discussion may lead the teacher to give a considered form to his own intuitive understanding of how children develop in art.

Where are the common factors in the work of children and what are the main causes for variation in their work? Jean Piaget, the most eminent of development psychologists, has indicated that children's cognitive development changes in a predictable pattern and that the type of cognitive operations a child is able to perform are related to his age and stage of development. Piaget distinguishes four stages in the development of intelligence: first, the *sensori-motor* period before the appearance of language; second, from about 2 to 7 years of age, the *pre-operational* period which precedes real operations; third, the period from 7 to 12 years of age, a period of *concrete operations*; and finally, after 12 years of age, the period of *formal or propositional operations*. For the purposes of this book only the last two will be discussed, but it is hoped that readers interested in delving a little deeper will read Beard (1972) or Piaget (1955) or Modgil (1974).

*The stage of concrete operations*
One of the difficulties of using Piaget when discussing stages of development for art is that the majority of his work is based upon the child's cognitive operations. It is left to the reader to translate Piaget's stages into his own understanding of children in a particular age range. Modgil helps here:

> Briefly, during the stage of concrete operations (approximately seven to eleven years) mobile and systematic thought organizes and classifies information. Thought is no longer centred on a particular state of an object. It can follow successive changes through various types of detours

and reversals, but because the operations are tied to action they are concrete rather than abstract. The attainment of the act of reversibility is the main feature in the development of the child's transition from pre-operational to concrete-operational thought.

(Modgil, 1974, pp. 10–11)

In general, concrete operations are those actions which are not only intuitive and subjective, relating to the child's viewpoint of the experience as in the previous stage, but also actions which relate to others to form general reversible systems. (A reversible action is one which can be retraced by opposite action.) The world in which the child lives becomes explicable in quantifiable, spatial, and physical terms. The pupil begins to understand that his world is structured by classifying, serializing, and grouping. Physical action at this stage begins to be 'internalized' as mental operations. Coupled with this, the child becomes less egocentric and starts to work and play in groups.

> During the sub-period (of concrete operations) we shall see that the children master even complex relationships. They classify or make series in two or more ways simultaneously, imagine views from vantage points other than their own, measure with reference to two axes at once, appreciate the inter-relationship of a whole with its parts or a class with its sub-classes and so on. Nevertheless thinking at this level of concrete operations shows some limitations. These appear in children's difficulties with verbal problems, their attitudes to rules and beliefs about the origins of objects and of names, their procedure by trial and error rather than by testing hypotheses in solving problems, inability to see general rules or to accept assumptions, and failure to go beyond the data provided or to imagine new possibilities or explanations.
>
> (Beard, 1972, p. 79)

Teachers will recognize many of the activities which demonstrate this stage of development in the pupil. The fervent desire to collect and classify stamps, car numbers, old bottles. Their desire to understand museum collections, play complex board games and negotiate new rules for old games, make working models, plan theatrical productions, and classify dinosaurs, plants, and birds. In art they want to deal with their environment in terms of what they see. They appreciate the similarities and differences between common objects. Their drawings are as much concerned with classification, identification, differentiation and so on as they are with expression of fantasies or ideas. They will be just as happy drawing the details

of the shops, cars, and people in the high road as they will be expressing their feelings about Christmas and bonfire night.

*The stage of formal operations*
It would be best to consider that the transition from concrete to formal operations takes place somewhere between the beginning of the first year at secondary school and the beginning of the fourth year. The difficulty for the art teachers is that strategies for first year pupils of about 11, based upon the manipulation of elements of visual form, could be ideal for some children and years too early for others. For this reason it is advantageous for the art teacher to be able to discriminate between children in either of the last two stages or in transition between them.

The formal stage of operations is characterized by the ability to deal with formal, abstract thought operations. The child becomes capable

> of reasoning, not only on the basis of objects, but also on the basis of hypotheses and is able to perform 'operations on operations', in a systematic manner. The formation of hypotheses and of deducing possible consequences from them, leads to a 'hypothetico-deductive' level of thought which expresses itself in linguistic formulations of propositions and logical constructions.
>
> (Modgil, 1974, p. 12)

There is some doubt about the number of children who reach the stage of formal operations and those who only attain it in limited areas or for short periods. In view of this, teachers would be advised to adopt the teaching strategy for the operational stage only in the third and fourth years (particularly when dealing with the less able) rather than use it in the first year. The ideal teaching strategy would approach the pupils through content or material and leave the question of concrete or formal operations to be decided in the classroom. Any strategy for a group of pupils in this difficult transitional stage would have to allow for developmental factors like personality, environment, social and racial background, and forms of motivation. Formal operations arise from the need of the young adolescent to co-operate and discuss issues. Social life extends beyond the immediate family and classroom. Greater mobility, mass communication, and broader social groupings give opportunities to exchange ideas and evaluate self against children of like

age and adults. The group dynamic requires an extension of the ability to rationalize, collaborate, exchange viewpoints, and justify attitudes. This requires the flexibility to view alternative ideas, forms, and structures wherever they may occur. Critical awareness brings with it the need to look carefully at self, society, school, and parents. In order to challenge the rules and beliefs of others there must be an understanding of their nature and the means to formulate arguments. As the ability to understand differences and shades of opinion increases so does the tolerance of others.

> A number of other new capacities stem from the initial development in seeing many points of view. Firstly, the adolescent can accept assumptions for the sake of argument. Secondly, he makes a succession of hypotheses which he expresses in propositions and proceeds to test them. Thirdly, he begins to look for general properties which enable him to give exhaustive definitions, to state general laws and to see common meanings in proverbs or other verbal material. Fourthly, as we have already seen in his spatial concepts, he can go beyond the tangible, finite and familiar to conceive the infinitely large or infinitely small, and to invent imaginary systems. Fifthly, he becomes conscious of his own thinking, reflecting on it to provide logical justifications for judgements he makes. Sixthly, he develops an ability to deal with a wide variety of complex relations such as proportionality or correlation.
>
> (Beard, 1972, pp. 98–9)

The adolescent becomes detached from his own egocentricity and becomes a more objective observer. There is a growing consciousness of self with advantages and drawbacks. The pupil can become highly critical of his own work and expect positive help to achieve the accepted standards of society or children of the same age.

It is increasingly believed nowadays that success can be achieved by formal teaching methods. The stated aim of the art teacher to help the pupil to become a non-conforming individual may cause frustration and confusion when placed against his 'formal' development in more cognitive areas of study.

> ... the adolescent's capacity to take different viewpoints enables him to see similarities in meaning; and he learns to make full use of similes and metaphor. His imagination is enriched by varied experiences and his powers of verbal expression are extended, enabling him to make allusions as well as assertions, but he does so within the limits of a logical possibility which replaces the illogical phantasy of childhood.
>
> (Beard, 1972, p. 103)

The art teacher should not be put off by the cognitive background to Piaget's work. It is difficult to relate the detail of his work to the experiences of the art teacher, but in general the stages of concrete and formal operations can give some insight into the way that pupils approach their work in the art room. At least it will help some teachers to understand why a superbly contrived exercise remembered from their foundation course does not work with the bottom stream of the first year!

## LOWENFELD'S STAGES OF DEVELOPMENT

Perhaps the time has come for Victor Lowenfeld's work to be critically reappraised, and Eisner has qualified some of his ideas (Eisner, 1974). Nevertheless, in terms of child development in the field of art no-one has had more influence than Lowenfeld.

Lowenfeld sees children's art as creative and feels that it should help in the development of self and healthy mental growth. All children can benefit in some way through art activity. The teacher's function is to arrange the conditions whereby the child can benefit fully. He sees any adult influence as inhibiting natural growth.

> The way creativity may be best realised is for the child to be exposed through all of his senses to the qualities of life. Through direct experiences with tactile, visual and audial phenomena the child's imagination and perceptual powers are developed.
>
> (Lowenfeld, 1965)

Lowenfeld's ideas are complex because whilst listing six developmental stages for children between two years and late adolescence he also defines seven areas where growth can be recognized and recognizes the development of two creative types.

Listed below are Lowenfeld's stages of development:

1 The scribbling stage – 2 to 4 years.
2 The pre-schematic stage – 4 to 7 years.
3 The schematic stage – 7 to 9 years.
4 The stage of dawning realism – 9 to 11 years.
5 The pseudo-naturalistic stage – 11 to 13 years.
6 The crisis of adolescence – 13 to 17 years.

Although in this section we will concentrate on the last three of his developmental stages, it will be necessary to mention the other areas in order to see the stages in a complete framework. Despite the fact

that this book is concerned with secondary education, the fourth
stage is being included so that the transition between primary and
secondary schools is not excluded.

### The dawning realism

This is the 'gang age'. Like Piaget, Lowenfeld feels that at this stage
the child recognizes himself as a member of his own age group,
working and playing with others, forming relationships, making
and breaking rules. There is a questioning of adult attitudes and
increasing development of social independence. There is greater
awareness of self and this, in turn, enlarges the range of relation-
ships formed although there is greater separation of the sexes.

The drawing of children at this stage is 'surprisingly similar to the
drawing of adults who have had no formal art training' (Lowenfeld,
1969, p. 184). By the 'gang age' schematic drawing is reaching its
final stage. With the growing awareness of differences and the
desire to classify schematic drawing is unable to support the degree
of differentiation which the pupil needs. Geometric lines are no
longer adequate. The human figure may still be stiff and immobile,
but there is greater observation of detail specifically related to the
subject. In drawings of the environment there is a more complex use
of several baselines and an awareness of planes. The child begins to
realize the significance of the horizon and the 'skyline' links with the
uppermost baseline. There is greater use of overlapping to express
the feeling of space. With increased awareness the expression of
emotions by exaggerated size decreases and is replaced by a concen-
tration of detail in the crucial part of the picture. There is an almost
obsessive concern for detail to characterize the environment. The
subjective 'X-ray' drawing is no longer acceptable to the child. The
use of colour becomes more subjective and, although the choice of
colour is still related to the colour of the object, there is increased
awareness of colour differences and similarities. Colour is also used
subjectively in expressing emotional experiences. This increased
awareness is often most obvious when it is a question of the observa-
tion and classification of objects in the environment. Children are
now aware of the shapes and colours of natural and man-made
objects. From this observation the pupils develop an interest in
decoration, design, and pattern. This is not a formal consideration of
design elements but work derived from printing of found objects
and the manipulation of materials into simple forms. This is the time

Table 8.1 *Stage of dawning realism (9—11 years)*

| Characteristics | Human figure | Space | Colour | Design | Motivation topics | Materials |
|---|---|---|---|---|---|---|
| Gang age. Removal from geometric lines (schema). Lack of co-operation with adults. Greater awareness of the self and of sex differences. | Attention to clothes (dresses, uniforms) emphasizing difference between girls and boys. Greater stiffness as result of egocentric attitude, and the emphasis on details (clothes, hair, and so forth). Tendency towards realistic lines. Removal from schema. | Removal from baseline expression. Overlapping. Sky comes down to base line. Discovery of plane. Filling in space between base lines. Difficulties in spatial correlations as result of egocentric attitude and ack of co-operation. | Removal from objective stage of colour. Emphasis on emotional approach to colour. Subjective stage of colour. Colour is used according to subjective experience. | First conscious approach towards decoration. Acquaintance with materials and their function. | Self-awareness stimulated by characterization of different dresses and suits (professions). Co-operation and overlapping through group work. Subjective co-operation through type of topic, e.g. 'We are building a house'. Objective co-operation through team work. | Paper cutting. Crayons. Poster paint. Flat, coloured chalk. Clay. Papier-mache. Wood. Collage materials. Metal. Prints. |

(Lowenfeld 1969, p. 399)

when pupils will explore the nature of materials and learn their inherent qualities.

At this stage the pupil is pulled in two directions: firstly, to conform to the pattern of his peers; and secondly, to express his own idea in his own way. He responds to both. The teacher needs to plan very carefully so that the syllabus does not operate at the child's expense otherwise the cost will be paid with interest during adolescence.

*The pseudo-naturalistic stage (11–13 years)* Victor Lowenfeld emphasizes the significance of this stage immediately before what he calls 'the Crisis of Adolescence'. He sees it as the bridge between childhood and adulthood. As the pupil's critical awareness increases it produces a lack of confidence in his ability to draw or make satisfactory images. Lowenfeld believes that the way to make the period of transition as smooth as possible is to make the child aware of success at a time when he is not sufficiently aware of it himself. Praise should be given once the creative activity is completed so that spontaneity is not lost. The teacher can then draw attention to the strengths of the pupil's work and foster an awareness of them.

At this stage, the child is still projecting his personality into his work without inhibitions. Considerations of beauty or perfection play no part. Pressure to conform to external standards nevertheless interrupt the direct flow of his work. The main problem at this stage is that the child not only wants to be liked by his peers and respond to their expectations but he also wants the respect and attention of adults. This poses a problem for the teacher in so far as their pupils will respond positively to the demands placed upon them by the teacher whether or not they allow him to express his own reality. It is the price he is willing to pay in order to gain respect and attention. Teachers, in turn, may view this attitude approvingly as the easiest way to produce pleasing work and classroom control, but as said previously the cost will have to be paid later.

At this stage the range of ability is wider within an age group than previously. Some pupils will still be using schematic images whilst others will have moved far beyond these into drawings demonstrating increased naturalism. Individual children may oscillate between the two depending upon their approach or involvement with the subject.

Lowenfeld makes the point that children have not yet developed

full control over their emotions and suggests that these can be utilized within the art lesson. In this type of work there will be exaggeration and over-emphasis in the colour and form of the work; this should be shown to be an acceptable approach so that the child becomes aware of the range of possibilities open to him. Children should not be expected to respond to the teacher's idea of art, the teacher should draw out the child's ideas and expressions. Lowenfeld uses perspective as an example of the imposition of adult artistic ideas on minds 'before they were psychologically ready for such teaching'.

As perceptual awareness develops children include texture and tactile sensations in their work. This sensitivity to texture cannot be 'taught', it must derive from sensory experience.

In drawing the human figure joints start to appear in arms and legs. Sexual differences are expressed in the drawings through exaggeration of sexual characteristics and greater detail in the clothes of both sexes.

During this stage the pupils are becoming increasingly aware of the whole design of their work; how colour is used, how to get the picture organized, what to include and exclude. This awareness should be encouraged but Lowenfeld adds, 'It should be emphasized that this is not the time to teach the formal elements of design, but rather children can be made aware of the beauty in what they are doing'.

The teacher must encourage the appropriate use of materials to express ideas. It is obvious that clay is not the best material to express 'the rainy day'. Children at this stage are ready to appreciate the qualities of materials and understand the range of their use both functionally and expressively.

At this stage it is necessary to introduce Lowenfeld's idea of the two main creative types and Lowenfeld uses them to emphasize that all work should derive from the personality of the child. These types are not distinct but reflect operational extremes. The extreme 'haptic' or 'visual' types are relatively rare and often both tendencies are expressed.

*The 'visual' type*   This starts from the child's perception of the environment which he experiences as a spectator. The intermediaries for experience are mainly the eyes. His drawing will record the folds in a dress, the wrinkles in a face. His drawings of

space show an awareness of relative size and some awareness of perspective. The 'visual' pupil will be much more concerned with form and colour than tactile qualities.

> Through his drawing, the visual type wants to bring the outer world closer to himself, whilst the haptic type is above all concerned with projecting his inner world into the picture. In the pictures of the visual type we shall always find that visual experience such as colour contrast between light and dark are particularly emphasized ... in this type 'the sense of sight is always the final court of appeal'.
>
> (Lowenfeld, 1965, pp. 89–90)

*The 'haptic' type*   This child expresses everything through his immediate bodily experience. The extreme haptic type of individual uses his eyes only when compelled to do so.

> The main intermediary for the haptic type of individual is the body self-muscular sensations, kinesthetic experiences, touch impressions, and all experiences that place the self in value relationship with the outside world. In haptic art the self is projected as the true actor of the picture whose formal characteristics are the result of a synthesis of bodily, emotional and intellectual comprehension of shape and form. Sizes and spaces are determined by their emotional value in size and importance. The haptic type is primarily a *subjective* type ... the haptic individual will arrive at a synthesis of (his) partial impressions only when he becomes emotionally interested in the object itself.
>
> (Lowenfeld, 1969, pp. 261–2)

> The haptic individual interacts with the world as a participant rather than as a spectator. He undergoes experience in a highly effective and kinesthetic way; hence, his drawings and paintings are not literal but emotionally exaggerated. Haptically-minded individuals tend to produce drawings that represent the feelings they undergo as a result of percep-tion rather than representations of their visual perceptions of the object's qualities.
>
> (Eisner, 1972, p. 91)

### The crisis of adolescence

Lowenfeld feels that 'a conscious critical awareness now dominates all the creative production of the adolescent individual'. (Lowen-feld, 1969, p. 257.) The pupil loses the subjective attitude towards his own creation and there is a growing lack of confidence and security in his work. There is a tendency to give up art as a means of expression at this stage. 'One of the most important tasks of art

Table 8.2 Pseudo-naturalistic stage (11–13 years)

| Characteristics | Human figure | Space | Colour | Design | Motivation topics | Materials |
|---|---|---|---|---|---|---|
| Developed intelligence yet unawareness. Naturalistic approach (unconscious). Tendency towards visual or non-visual-mindedness. Love for dramatization and action. | Joints. Visual observations of body actions. Proportions. Emphasis on expression by non-visually minded. | Urge for three-dimensional expression. Diminishing sizes of distant objects. Horizon line (visually minded). Environment only when significant (non-visually minded). | Changes of colour in nature for distance and mood (visually minded). Emotional reaction to colour (non-visually minded). | First conscious approach to stylizing. Symbols for professions. Function of different materials, with related designs. | Dramatic actions in environment. Actions from imagination and posing (with meaning, like scrubbing). Proportions through emphasis on content. Colour moods. | Water colour. Gouache (water colour and tempera). Poster paint. Bristle brush. Hair brush. Clay. Linoleum. Papier-mache. Textiles. Wood. |

(Lowenfeld, 1969, p. 400)

education during this vital period is to introduce means and methods of stimulation that will prevent the child from losing self-confidence'. (Lowenfeld, 1969, p. 257.) At this stage Lowenfeld emphasizes the differentiation of the two creative types in the way they approach art. He suggests that about 70 per cent orient themselves to the world in one of these types. The remainder, whose reaction is not definite in either direction tend to express their creative concern through abstraction.

In figurative work there is a tendency to identify with the figure in terms of the activity. There is an awareness of action, clothing and movement. The visual type emphasizes the appearance of the object, relative proportion, light and shadow, and the 'snapshot' effect of momentary impressions. The main drive is towards naturalistic interpretations of objective validity. The haptic type emphasizes inward impressions and emotional qualities. Relative proportion is based upon value judgement rather than visual perception. The pupil concentrates on interpretation and characterization. The same pattern emerges in the treatment of space. The visual type is concerned with some form of perspective, using diminution of the relative size of distant objects or atmosphere changes in colour and tone. He emphasizes the three-dimensional qualities using light and shadow. The haptic type uses the perspective of value in relation to self and tends to use baseline expressions of space.

The visual type uses colour as it appears in nature and becomes aware of colour reflections, changes in the quality of light in terms of distance, mood, time or season. An analytic attitude to colour develops. The haptic type uses colour expressively and gives it subjective meaning. Local colour is used when significant, in other words when related to emotional and psychological significance.

In design the visual type is concerned with aesthetic interpretation of form balance and rhythm. The haptic type produces emotional designs of abstract quality or removes himself from personal expression to work on functional or industrial design.

### Individual, social and cultural emphasis

Teachers place the main emphasis of art teaching on the benefit to the individual. This was made very apparent in the response by a group of about ten art teachers to a questionnaire on the subject and in research done by Miera Stockl (see page 135).

Table 8.3 Adolescent art (13–17 years)

| Characteristics | Human figure | Space | Colour | Design | Motivation topics | Materials |
|---|---|---|---|---|---|---|
| Ambition. Energy. Romantic ideals. Introspection. Peer group pressure. Sexual awakening. | Action. Participation. Self-identification or empathy. Clothing. Costume. Dance and rhythm. | Visual perspective or perspective of value. | Sophisticated. Not necessarily naturalistic. | As integral part of function – in furniture, clothing, ornament, architecture, home style, site, landscaping, interior decoration. Appreciation. Abstract. Cartoons. | Self, home, community, industry. Explore materials rather than emphasize technical excellence. Develop sensitivity. Excursions. | Any materials that contribute to further growth or adult use. All previous materials, plus photography, ceramics, wood (constructing and carving). Natural materials. |

(Lowenfeld, 1969, p. 401)

The heads of art departments were asked to rate twenty-four suggestions for important functions or purposes of art in the curriculum. The suggestions which received the most universal support were:

(a) To develop more sensitive visual perception.
(b) To encourage growth of imaginative ideas.
(c) To provide opportunity for individual or personal expression.

Not a single teacher participating in the survey disagreed with these three objectives. It was interesting that the suggestion that the pupils should be given: 'A background understanding of cultural forms (art, architecture, etc.)' was seen as an important but *secondary* objective for art education, by a large proportion of the art teachers.

The two suggestions which received the *least* support were:

(a) To provide a service for the school (e.g. graphics, model-making, etc.)
(b) To develop an understanding of technological processes.

It may be helpful to bear in mind the objectives considered to be of most importance by the majority of art teachers, when considering more closely some of the forms of integrated activity which are currently emerging in the schools.

(Stockl, 1973)

Despite this emphasis on the individual much of the teaching in practice has strong social and cultural overtones. Most practising teachers seem to want to work for and towards the individual reality, but many writers on art education emphasize the appreciation of art as the experience of something 'out there'.

What is art education for? Should it inject a socialized or culturalized input into society and conform to the accepted norms or should it enrich society through the development of unique individuals able to diversify and change the norms? Academics often emphasize the social importance whereas grass roots' educationalists still believe in open ended enquiry.

Manuel Barkan suggests an appropriate goal for the art curriculum, namely, 'to increase the student's capacity to experience aesthetic qualities in the arts and the general environment' (Barkan, 1970). This goal is aimed at the student and the arts come across as something 'out there' particularly when he breaks them down into a list:

1 Responding to aesthetic qualities in one of the arts.
2 Producing aesthetic qualities in one of the arts.
3 Responding to, or arranging, qualities in the general environment.

Dick Field comments:

> ... however one achieves an aesthetic experience – whether by doing or looking – the experience is still the same. ... There is surely a hint here that a fruitful field of experience and discourse might lie in the relationships between the arts – and therefore by implication, might draw on the aesthetic experience as gained by looking and listening, rather than through making. ... I am sure that the aesthetic experience is greatly enriched by some knowledge of history and iconography. I do not believe that very many of today's students could respond to much contemporary work without some knowledge of how it came about. ... In considering these specific goals, it immediately becomes clear that mere activity will not do – there must be consideration, dialogue, planning, and evaluation.
>
> (Field, 1973)

Brian Allison emphasizes the role of art education in helping the school-leaver fulfil his

> community role as a public representative making decisions about architects' proposals, artists and designers' plans, museums and art gallery commitments and many other matters requiring sound, informed and educated aesthetic judgement and discrimination. ...
>
> It is clear that the development of such education sensibilities does not occur solely as a result of having painted or printed a few pictures, having made a few junk or other sculptures or having designed a few pigeon lofts or dog walking machines.
>
> (Allison, 1974)

Allison sees art in art education as something one has a relationship with rather than an activity through which personal experience is perceived and understood. He criticizes the Schools Council's Curriculum Project, 'Art/Craft 8–13'.

> Children's relationship with art and children's art products were only conceived of as *making* art. Yet the products of engagement in art activity need not be, nor for the majority of people are they likely to be, material artefacts nor need that activity itself be only one of the manipulation of materials.
>
> (Allison, 1974)

Note his continued use of the word 'relationship' *with* art. Art is suggested as an 'out there' experience. One's relationship with it can be controlled to achieve required objectives. In this case the object is to create a member of the community capable of making discerning decisions in the general field of art. Although he

considers that the 'manipulation of experience is of the utmost importance, and is certainly essential in the development of those sensibilities referred to earlier' the emphasis is on the *social application* of these sensibilities even though they were learnt or developed through the pupil's direct experience. The essence of his belief is that

> art education has a responsibility for such diversification as is necessary to make a wholly meaningful contribution to an individual's sensibility and sophistication *based upon a realistic appraisal of the relationship with art* that that individual could, and if adequately educated, would have.
>
> (Allison, 1974)

This 'out there' definition is re-emphasized in his use of Efland's definition of the outcome of an adequate art education.

> To be 'educated in art' means considerably more than being able to manipulate some art materials, however skilful and expressive that manipulation might be. It also means to be perceptually developed and visually discriminative, to be able to realise the relationships of materials to the form and function of art expression and communication to be able to critically analyse and appraise art forms and phenomena to be able to realise the historical context of what is encountered and to be able to appreciate the contributions to, and functions within, differing cultures and societies that art makes.
>
> (Efland, 1970)

The social and cultural approach to art is more respectable and is more acceptable to people who have little or no understanding of the fundamental role that art plays. This has encouraged many art teachers to see this approach as a way of achieving 'recognition' and consequent support for what they want to do. It is adopted by the art teacher as a means of achieving an increased allocation of resources that are not forthcoming when using a more child-centred strategy. As Bernard Forman says:

> It seems quite probable that many well-meaning and sincere art educators have seized upon the apparent trend towards more concern for 'quality' (aesthetic or otherwise) and the inculcation of basic drawing and design skills with some measure of relief. Not only has the current involvement with more readily evaluable fundamentals provided a comfortable feeling of respectability, but it has served to reinforce and lend moral support to those who probably have never really been able to acquiesce wholeheartedly in the equalitarian, non-conformist, iconoclastic implications of the

philosophy of creative Art Education – and its equivalents in other areas as well. But, by and large, the bulk of evidence seems to indicate that, among the majority of 'grass roots' art educationalists at least, the philosophy of Art Education still rests on a solid foundation of continuing, open-ended investigation into the nature of art expression along with efforts in the areas of the identification, typology and taxonomy of creativity.

(Forman, 1973)

This does not mean that social and cultural aspects of art are irrelevant. They can be used to reinforce the process through which the pupil is educated but they should be part of the means towards an end which is located essentially within the individual reality of the pupil. Eventually, within the complete and continuing education of the individual, it will be up to him to decide how he wishes to relate his own reality to social reality and during the process of art education he should be given opportunities to discover the nature and form of social and cultural reality. As Peter Berger says,

Social psychology has brought about the recognition that the sphere of psychological phenomena is continuously permeated by social forces, and more than that, is decisively shaped by the latter. Socialization means not only that the self-consciousness of the individual is constituted in a specific form by society (which Mean called the social genesis of the self) but also that the psychological reality is an ongoing dialectic relationship with social structure.... Self and society are inextricably interwoven entities. Their relationship is dialectical because the self, once formed, may act back in its turn upon the society that shaped it. *The self exists by virtue of society, but society is only possible as many selves continue to apprehend themselves and each other with reference to it.* (My emphasis)

(Berger, 1971)

## Fact or feeling? Cognitive or affective?

The present education system tends to be one-sided, because certain aspects which do not conform to established social attitudes towards knowledge and learning are neglected or inadequately provided for in our school curriculum, especially from nine years onwards. This educational deficiency has been recognized by many people. The general imbalance in education could be rectified if the role of the arts was more clearly understood, both inside and outside the disciplines which comprise it. The cognitive domain of educa-

tional objectives dominates most of the educational strategies to be found in secondary education at present.

> The Cognitive Domain classified education objectives which involve intellectual tasks. For some of these objectives the student has to do little more than remember; for others he must determine the essential problem and then re-order given material or combine it with ideas, methods or procedure previously learned.
>
> (Bloom, 1956)

Nine years later Bloom wrote of

> the Affective Domain categorizing objectives which emphasize a feeling line, an emotion, or a degree of acceptance or rejection. There are five main sequential stages in affective objectives. Receiving; Responding; Valuing; Organizing; Characterizing by a value or value complex. It is the domain of personal response.
>
> (Krathwohl, Bloom, and Masia, 1964)

It is the affective domain which is neglected in our schools.

It would be easy to epitomize the two sides of education as cognitive and affective, but this is only one perspective. A different approach is proposed by Robert Ornstein, who refers to the duality of the brain and defines different operational functions of the left and right-hand sides. His thesis was explained in a New Scientist article:

> Now we know that analytical processes (including logic and speech) are generated in the left hemisphere, and intuitive processes (including body movement as in ski-ing and 'artistic' talents) are found in the right hemisphere. In other words, sequential information processing occurs in the left hemisphere and simultaneous processing in the right. He suggests that Western education suppresses right hemisphere development because pupils are crammed full of left hemisphere experiences – the activity of one hemisphere is inhibited by the activity of the other. This means that there is an enormous waste of problem-solving capacity in the products of our education system. By specifically training each hemisphere with appropriate tasks, a person will be able to bring both approaches to tackling problems – analytical and intuitive, each activity being switched on separately. This won't make us all into geniuses, says Ornstein, but 'it will increase those capacities associated with what we call genius'. But Ornstein complains that Western education and culture stress the value of one and almost disdains the other. 'A great mind is too often associated with a great mouth,' he says.
>
> (Lewin, 1974)

Education in general tends to emphasize socialization; it is therefore of great importance that art should help to counter this influence and emphasize the personal reality so that the dialectic is more balanced. The balance of the curriculum requires that the art teacher understands the essential function that he performs no matter where he stands with regard to the dichotomy between social and individual reality.

Edward de Bono (1977) has emphasized the lateral versus the vertical modes of thinking and enquiry. Liam Hudson (1967) has explored the nature of convergency and divergency.

Professor Bantock has asked that we use alternative modes of communicating and learning for people with different learning styles or needs.

> Can we find a syllabus which will be at once demanding but which, based upon different principles from the current one, will afford greater opportunities to those who at present show little aptitude for the cognitively based curriculum? I believe it is possible, and that its basis should be affective – artistic rather than cognitive intellectual . . . there is a need for an education of the emotions in ways which our cognitive curriculum sorely neglects.
>
> (Bantock, 1971)

The divisive implications of his approach may not be accepted, but his support for affective education should not be ignored.

The Hadow Report (1926), Plowden Report (1967), and Newsom Report (1963), which are surely not to be thought of as particularly radical, also have interesting things to say about these neglected aspects of education. The Hadow Report comments that

> the curriculum is to be thought of in terms of activity and experience rather than of knowledge to be acquired and facts to be stored.

The Plowden Report states that

> the great majority of primary schoolchildren can only learn efficiently from concrete situations as lived or described . . . according to Piaget, all learning calls for organisation of material or of behaviour on the part of the learner and the learner has to adapt himself and is altered in the process. Learning takes place through a continuous interaction between the learner and his environment which results in the building up of consistent and stable patterns of behaviour, physical and mental. Each new experience reorganises, however slightly, the structure of the mind and contributes to the child's world picture.

The Newsom Report recommends that

> the value of the educational experience should be assessed in terms of its total impact on the pupils' skills, qualities, and personal development not by attainment alone.

Professor Hirst, however, still epitomizes much of the thought on the school curriculum and gives massive support to those that consider the core of education to be linguistic and abstract, and cognitive.

> As I see it, the central objectives of education are developments of mind. ... No matter what the ability of the child may be, the heart of all his development as a rational being is, I am saying, intellectual. Maybe we shall need very special methods to achieve this development in some cases. Maybe we have still to find the best methods for the majority of people. But let us never lose sight of the intellectual aim upon which so much else, *nearly everything else*, depends. Secondly, it seems to me that we must get away completely from the idea that linguistic and abstract forms of thought are *not* for some people.
>
> (Hirst, 1967)

The science and mathematics teachers, epitomizing the cognitive side of education, recognize and value efficiency, organization, and control. The arts teacher, on the other hand, feels it dehumanizes the essential nature of what he sees as his responsibility. The cognitive behaviourists see the artist as a muddling anarchist unable to explain himself in terms of the models which the scientist himself has created to explain *his* strategies. The arts teacher, in refusing to adopt these models because he sees them as patently inappropriate, usually neglects or refuses to create his own means of specifying what he is doing.

## Conclusion

There are other areas of conflict within art education. Those dealt with briefly in this chapter are those which tend to bedevil the early stages of discussion about the function of art education within the curriculum. Some, in frustration, will leave before any resolution of the problems has even been attempted. Many art teachers hold their ideas with such deep conviction that they cannot believe that any-one with an understanding of art could possibly hold contrary views. Place a marxist with strong social environmental views

against a cultural academician and watch the sparks fly before dead-lock sets in. Many art teachers will already be feeling frustration at the 'jargon' used in this book. Jargon can be the words that one set of people use to describe the activities of others. In the formulation of ideas there must be agreement about the meaning of words that they choose to use. If 'teaching strategy' sounds too grandiose then use 'the decisions we are going to make about the way in which we teach'. As long as all members of a discussion group understand the meaning of the words they are using they could call it anything. A glossary has been included to give the meaning of words or phrases in this book.

Another problem worth mentioning is the belief held by many art teachers that words are an inadequate way of communicating the art experience. Some even consider those that attempt to do this as something less than artists. I have seen several excellent visualized forms of ideas about art education. Their clarity of meaning is excellent for some and totally esoteric for others. Their general usefulness is limited because they are specific and idosyncratic. Their chances of wide publication are limited. In spite of this prob-lem, the use of visual forms by a group of art teachers discussing art education will help some teachers to introduce ideas which they could not have otherwise articulated verbally.

Finally, many art teachers despair of ever communicating the quality and nature of their work to teachers of other subjects. With-out suggesting that they are all willing and able to understand everything we do immediately, at least some of the difficulty arises out of the art teacher's unwillingness and inability to deal with the problem. We are sometimes seen as a Cinderella subject. The Prince Charming, capable of altering our status, will have to be gifted not only as an art teacher but in his ability to demonstrate the value and quality of everything we do to our colleagues.

# 9 Environmental influences

Chapter 8 dealt with issues where the attitude of the art teacher can crucially influence the statement of aims and worthwhile outcomes. There are other, more specific, constraints created by the nature of the immediate environment. An excellent course designed for a multi-racial urban community school, housed in nineteenth-century buildings, with a head teacher convinced of the value of 'selling' the school through performances, exhibitions, and service to the community, might be totally inappropriate for a small, post-war, rural school where the success of the art department is measured by the head teacher on the basis of GCE examination results. An art teacher moving from one kind of school to another does not need to change his basic philosophy. He does need to adopt alternative procedures to achieve the same quality of experience for the pupil. To hold fast to carefully considered concepts, procedures and criteria, as a matter of conviction and principle, whilst restructuring the use of resources, requires flexibility and the ability to negotiate. It also needs the qualities of a good intelligence officer, personnel manager, entrepreneur, psychologist, sociologist and security officer.

This chapter looks at some of the attitudes likely to be encountered by the art teacher and to influence the strategy for dealing with art education.

## The attitude of the pupils

When pupils enter schools family, friends, the community, the mass media, and so on have already had more influence on them than any

art department in the country can ever hope to exert. Eighty minutes per week can do little to counter the effects of this conditioning. To make matters worse, the educational establishment in general does very little towards fostering a serious attitude towards the arts and sees them as peripheral cultural or social trimmings unrelated to the main business of education. (More money has in fact been spent by the Schools' Council on the development of the Welsh language than on all the arts in education.)

This attitude is evident if one considers the difference in allocation of time for art between the gifted and the less able pupils. Streaming by option in the upper secondary school is structured to encourage the gifted to study cognitive subjects, with the arts seen as a useful filler for the less able. Consequently, a considerable amount of time and energy has to be expended by the art teacher in remedial work and in fostering an interest in the subject, before the simplest educational work can be started. This may need to be a factor built into the syllabus, in the same way as remedial reading and mathematics. A pupil with a poor attitude towards reading is seen as a very serious problem, but such a deficiency in art hardly worries anyone. The tendency to look on art as a poor option is probably more apparent in pupils gifted in cognitive studies because they are more responsive to the attitude of some of their teachers, who present the arts as trivial and unimportant and therefore not warranting serious study.

> In a survey of six schools (1st/5th years) the actual curriculum devoted 10.5% of the time to Art, Music, and Drama. When consulted, the pupils proposed 19.5% of the time should be devoted to them.
> (Schools Council Working Paper 54, 1976, p. 36)

> Arts lessons were usually fun . . . I met few pupils who wished to drop the Arts and many who regretted having to give up these subjects or choose between them. Of course, the Arts subjects were not 'important' and doing Art or Drama or Music was not 'work' but most of the girls and boys I spoke to looked forward to these lessons and for one or two children in every school the particular relationship with an Art teacher was essential to their basic stability and to their functioning in the school at all. As 'time off' the Arts were doing a useful job.
> (op. cit, p. 19)

The attitudes of pupils towards art is different from school to school depending on many factors. The most important way in which these attitudes can be improved is through art teachers building a positive and open relationship with their pupils. This is the best way art

teachers can demonstrate the importance they attach to personal attitudes, values, and judgements. Art as a subject discipline is second to none in the opportunity it offers to practice what one preaches. There is no better way of convincing pupils of the serious value of art than by art teachers discussing the type of exploration being undertaken in the realm of art. The quality and success of art work is of less importance than the decisions made in the process of creating it.

It is also important to keep in mind that the attitude of children is influenced by their stage of development, particularly as it relates to their peers. As social attitudes change so will the response of pupils. Strategies worked out for pupils in the 1960s need to change to accommodate the changing social attitudes of the 1970s. This is particularly so after the age of 13 years. It requires more than a change of subject matter from 'space travel' to 'skateboards'. Motivation nowadays must take into consideration the pupils' attitude to work, art, and leisure much more than in the previous decade when children responded much more unquestioningly to teachers' suggestions than is usual in schools today. The next ten years will probably show comparable changes of attitude, requiring further reconsideration of art teaching methods.

**The attitude of the schools**

Ideally there should be a congruency between the ethos of the school (normally determined by the attitudes of the head teacher and the teaching staff) and the attitude of the Head of the Art and Craft Department. As an art teacher it is pointless setting up a scheme of work which is unacceptable to some members of staff who are in charge of the allocation of resources and which risks engendering resentment and reaction in the pupils. I am not suggesting that the essential justifications for art education should be forgotten but that there are alternative ways of achieving similar outcomes. The common factor in all schools is children, the rest is politics. It is the responsibility of the art staff to make the most effective contact with the children within the constraints placed upon them. At the same time, they should work to ameliorate the constraints as a means of improving their contact with the pupils.

The most striking feature of my discussions with Art teachers was their vagueness and confusion when pressed on the questions of immediate

educational goals and long term objectives. There appeared to be no general agreement among them concerning their own function in relation to their pupils, or of the function of the Arts in the educational process. A natural consequence was their anxiety over the whole question of validation – of their own work and that of their pupils. Many complain of being held in little professional esteem by the staff as a whole and all gave the impression of working lives lived in some degree of isolation. Few of them had any clearly developed ideas about either integrating the Arts or about connecting with the real lives of their adolescent pupils.

(School Council Working Paper 54, 1975, pp. 12–13)

Art teachers would achieve a great deal for their pupils, themselves and their schools if they were more willing to articulate what it was they were actually doing in the art room and indicate the range of outcomes they wished to foster through this activity. Art education is not only about the mystery of art, it is also to do with the education of the pupils. Some art teachers might be very surprised by the depth of understanding which teachers in other subjects have about the specific role of their subjects in the whole curriculum whilst at the same time having the ability to understand well-founded arguments about the roles of other disciplines. There are often more teachers from other disciplines on art courses than art teachers on courses not directly related to art.

The idiosyncratic nature of the art department is often recognized by other staff and at the Drama Advisers' Conference in 1976 there was considerable debate about the 'messianic arrogance' of some drama teachers. This quality can also be recognized in other fields of art education.

•Art education has the human, intellectual, and technical resources to communicate its value to pupils and colleagues. The understanding of many headteachers and staff from other disciplines of the function of art in education is based upon very limited personal experience. Most of them were probably obliged to give up art at an early age. If we work on the basis of present-day attitudes towards the subject, we could assume that more than 50 per cent of our colleagues did not take art beyond the third year of secondary education. Those who did include it in their fourth, fifth, and sixth year options probably studied it within a GCE structure. Their view of art is bound to be far more limited than the art teacher's view of, say, language, literature, and mathematics because the experience

of these subjects at school is seen as crucial, whereas art tends to be optional.

• The attitude of the school can only be made more receptive by a concerted effort on the part of art staff to demonstrate the particular value of their subject: This problem has been recognized by art teachers in the past but, unfortunately, many of them have succumbed to the temptation to conform to the wishes of the unenlightened, in order to further their position within the school structure. Excellent examination results, irrelevant schemes for integration, costumes and scenery for school plays, posters and tickets, magazine productions, curtains for the headteacher's study, exhibitions of the best work, have usually paid greater dividends than clearly articulated schemes of work. There is no doubt that this type of activity can be the best basis upon which to argue for more money, staff, working space, and resources. But in the final analysis art has not improved its position since the mid-1950s. In practical terms, the subject is allocated less space and deals with even larger classes. Art in the late 1970s is usually seen as eighty minutes per week for the first two years. The position of art education is further undermined through design education or creative art timetables which often reduce the yearly allocation of time for art by a third. Whilst art teachers may be convinced of the essential importance of their subject within the curriculum, they have often failed to win the confidence and support of those in command of the direction of curriculum and resources.

Individual art teachers may find they improve their position best by selling their subject as a support activity. But this is no basis upon which the profession as a whole should justify art in education. This can only be improved by a concerted effort to clearly articulate the fundamental importance of art for the pupil.

## The attitude of the community

At the time of writing the economic situation, unemployment, adult illiteracy, adult 'innumeracy', the lack of scientists and technologists, the radical changes in the educational structure of secondary schools, colleges, and polytechnics have all placed an increased emphasis on the need for cognitive development. The prospects for art in education in the immediate future do not look rosy. If we cannot have much hope of moving forward, we should resist the

temptation to justify our subject by rationales and strategies more acceptable to the cognitive and social hardliners. The rapid acceptance of design education during recent years should act as a warning. This approach attracts those educationalists who have failed to comprehend the meaning of art in the past and now find it easy to rally to a rationale and strategy with clear social objectives, practical procedures and relatively easy assessment in functional terms. Within five years, rooms have been built, staff appointed, and colleges have developed design courses. Much less encouragement has been given to integration in the other direction, across the arts, as opposed to the crafts.

This is not to support one attitude against the other. It is to make clear the dominant social attitude towards the arts. The 'national good' is too often seen in economic and material terms rather than in the quality of life. Art teachers must work hard to retain the importance of values, judgements, and attitudes in the educational process.

If convincing our colleagues is difficult then changing the attitude of the community must seem to be impossible! It is tempting through the public display of the work done by the children, to try to convince school managers and governors, PTA's, the local press and the odd parents that art has wonderful things to offer. This type of exercise can do little harm and may capture the audience's interest sufficiently to further question the reasons for doing art in schools. The opportunity to get to grips with a sizeable section of the community and put the case for art education are few and far between. Without the display of a fair number of generally acceptable artefacts the interest of all but a determined few is lost.

Individual teachers can do little by themselves. Most local art and craft associations are recreationally based and work from a viewpoint different from the art teacher's in schools. Art teachers, in any case, are not keen to join groups in order to show a common purpose; they would rather demonstrate their individuality and independence.

The National Society for Art Education, The Society for Education Through Art, The British Association of Art Therapists and The Association of Art Advisers have all, in their time and in their own way, made useful contributions to the debate on the function of art education. Some of these produce journals and bulletins and all arrange meetings and conferences. It must be admitted, however,

that their impact upon the attitudes of educational establishments and the community in general, even when coupled with the Department of Education and Science and The Schools Council, has been minimal in creating effective changes in attitude. These are harsh words but they are not intended to be a criticism of the efforts of these associations. I have been a member of, or involved with, sections of each of these at some time and am quite willing to share some of the responsibility in this matter. But for all of their good works and best intentions, they have less influence on people's attitudes than do the easily digested ideas put forward by the mass media. Television's children's programmes, art competitions, sponsors, Henry Pluckrose and a plethora of other writers offer a simple formula for making things and calling it art. Art teachers must recognize the barrenness of such ideas and accept it as part of their job in the classroom to fight back and encourage pupils to approach art seriously and with sensitivity.

Before the attitudes of the community towards art education can be changed, art teachers must find ways of articulating their own understanding of what they are doing. First of all, it must be done by art teachers, with art teachers, for art teachers. When this debate is clarified, the essential attitudes, values and qualities of art education must be brought to a wider audience of teachers and lecturers from all disciplines. From this standpoint art education will be equipped to communicate its aims and purposes to the general public.

During the recent debate on education (1977–8) inaugurated by Prime Minister, Jim Callaghan, and pursued by Secretary of State for Education, Shirley Williams, there has been little or no consideration given to art education. The national press and television has been almost totally silent on the matter. The educational press has touched upon it but in a desultory manner. Statements from the main associations for art education have been short, clear and to the point and yet, placed against such a paucity of debate amongst the majority of art teachers, their statements have the ring of hopeful rhetoric.

Recognized centres for the study of art education must be established. There is a tendency at present for research in art education to be peripheral and limited. The debate needs to start with the wider issues as they affect art teachers and their pupils. The work done within these centres, or by independent art teachers, needs to be made readily available through a well-edited periodical. The

functions of the different associations need not be changed. Diversification can be a spur to debate and enquiry. But it would be useful for all of them to be able to channel their ideas and research through local and national centres linked by a single national periodical edited by someone with the ability to recognize the need for an open ended approach to the subject.

At the present time (August 1978) the effects of some comments made by Elliott Eisner at a conference in Exeter, coupled with a British edition of the American publication *Art Education* and the links that Ernest Goodman and others are making with American art educators gives some hope that these ideas could be given substance within the foreseeable future.

# 10 Implications of the course design

## Staff

This aspect of course organization is the most sensitive and crucial. Staff should be appointed for their appropriateness within the total team and must understand their function and responsibility. They should only be offered the post and accept it if their function within the team has been clearly outlined. Where existing staff are inappropriate, ill-equipped, apathetic or antipathetic, the head of department is inevitably forced into a dominant role in order to support the rest of the team. The greater the degree of overlap of responsibility and similarity of attitude within the team the better, as long as all aspects of the conceptual and procedural framework are covered adequately. Teachers tend to have interests far wider than described in any particular aspect but not wide enough to cover the full range. It is necessary for the head of department to develop ways of overcoming deficiencies which exist between the total capabilities of his staff and the total coverage required by the course design. When a teacher is able to work on the basis of his own interests and expertise, within a framework where he can see other aspects outside his range of interest being covered by his colleagues, he gains confidence in the value of his own work, recognizes the value of what others are doing, and eventually widens the area of his own operations. The head of department should see this as the most fruitful area for the in-service education of his staff. He should encourage crossreference, crossfertilization, and recognize the value of the conflicts inherent within the design because of the idiosyncratic nature of the individual members of staff. The head of

department must work more widely than the rest of his staff in order to create a balanced strategy, but must also train his colleagues to extend themselves to remedy any deficiencies that become obvious. His object should be to create a framework which enables the idiosyncratic parts to form a cohesive whole.

## Integration

Once the department is operating effectively, individual members of staff should be encouraged to correlate with colleagues in other disciplines. When doing this they must be confident that the pupils will benefit from the proposed scheme of work; that their main subject responsibility does not suffer; that there is congruency of objectives between the staff involved; that there is no strong personality clash; that the necessary resources are available; and that the scheme is based upon sound educational principles with valid pupil objectives, and is not a teacher-based scheme for their own benefit.

The criticism could be made that if all these constraints are imposed very little would be started in this direction. On the other hand if these constraints were imposed it would be possible to avoid a great deal of wastage of time, space and resources on schemes that are doomed to failure from the start.

Many schemes for integration are imposed or suggested by head teachers as a means of solving some timetable problems, as much as for curriculum balance. Few schemes for integration, studied by the author during the past fifteen years, have served to increase the amount of contact time available for pupils. Sometimes there is a reduction of class size that brings art in line with home economics and handicraft but this has little to do with a recognition of the difficulties of teaching art to groups of thirty whilst other subjects are being taught to groups of twenty. Its main justification is the rationalization of timetable construction.

Misunderstanding about art education on the part of head teachers means that crude groupings like 'practical or workshop studies' are given more weight in curriculum planning than any serious consideration of shared concepts, procedures or criteria. There may be more in common between the aims of some art and English departments than between art and domestic science, but this is rarely recognized.

Any scheme for integration which reduces the effective teaching of art education within the time allocated should be treated with suspicion. The only value of integrated work is when it enables the art teacher to achieve all he could have achieved previously plus the bonus of breadth of study and the excitement of working in a mutually sympathetic relationship with a colleague from another discipline.

## Timetabling

The pattern of time allocation for art has become stereotyped in most of our secondary schools. New building schedules based upon 'the norm' allow little chance for any increase in length of lessons. The pattern is usually for periods of about forty minutes with thirty-five to forty periods in each week. The first and second year have two periods mainly in full classes of up to thirty pupils. Where the numbers are reduced to twenty, there is often a reduction of the total time allocated for art within the year through the operation of a 'practical subject circus', in other words the circulation of pupils around the practical subjects on a termly basis.

In the third year, art is usually on the core curriculum for two periods per week in classes of fifteen or twenty. During the first three years there is a good chance in a 'streamed', 'banded', or 'set' school for the less able pupils to be given more time for art. This is mainly because other teachers find the pupils less able to deal with the level of teaching which they have adopted for their subjects.

In the fourth and fifth years, children are presented with a range of options from which to choose. Art has an average take-up of about 50 per cent. Schools where art is encouraged and examination results and general motivation are good have a take-up figure of 60 per cent or above. In many schools, because of the nature of the option system, art teachers can only teach 30 per cent. The whole process can become a vicious circle. Fewer pupils opting for art may well reduce the art staff and allocation of space and money. When this happens it may be claimed that the art department is not equipped and staffed to take increased numbers. Once a pattern is set it is harder to increase the commitment than it is to reduce it. A further problem is that the pupils that have 'opted' for art are often manoeuvred into the subject because they are not felt bright enough

for other studies. The reverse can also happen when brighter pupils wishing to take art find that the options are organized so that art cannot be taken within the more academic range of subjects.

The sixth form tends to highlight the weaknesses hidden in the complexities of the lower school. Although workable groups of sixth formers opt for the subject they often have to be taught by teachers alongside other classes. There are many reasons for this, including having no room for the sixth form timetable so that it is only luck if art staff, accommodation and pupils are all free at the same time. A great deal of the timetable problem is caused by the determination to put the single academic periods on to the timetable first and then to try to fit the double and triple periods around them. A typical result of this is that for three days the art department is packed with children and all the art staff are working full-time, whilst for two days the department is dotted with stragglers and extra time for the remedial group. To add to the frustration the sixth form may only be free to do art by doubling in the crowded three days and the art staff may be used as the standby staff for staff absence in the other two days. A balance can be maintained. The secret is in locating the blocks of time early on in the timetabling process. In the same vein, art staff should refuse to double groups of sixth form pupils with other classes whilst, say, Mandarin Chinese and Computer Studies are being taught in isolated groups of two or three pupils.

The blocking of larger periods of time across a timetable creates opportunities for the time to be used flexibly between groups of teachers within or between subject disciplines (see p. 134 for an example of timetable blocking).

In a large eight form entrance comprehensive school timetable, four first year classes could go to the art department at the same time and a variety of possibilities could be permutated:

(1)  Each class could be treated as a distinct unit for one year with one teacher.

(2)  The same method as above could be adopted but with periodic changes of groups between the art staff in order to benefit from their different interests and approaches.

(3)  Team teaching methods could be used where the whole group is taught by all art teachers.

(4)  Team teaching could be used but with different sized groups to cater for different activities, e.g. small groups for work with clay;

normal class size groups for painting and drawing; larger groups for discussions, visits and group work.

(5) Groups could be formed on the basis of subject matter or technique.

If these periods were set along with similar blocking for handicraft, drama or any other subject, formal and informal correlation of limited or extended time could easily be arranged. In this way there would be no need for a special curriculum structure to be built into the timetable. This form of correlation creates opportunities without subject teachers being restricted into a prescribed scheme which does not allow them to follow their full range of possibilities.

The problem of a viable timetable for art education is not essentially one connected with practical difficulties; it derives more from attitudes of senior staff and the value which they put upon different subjects, examinations and higher levels of education. If the attitudes of those who control time, space and staff remain unchanged, so will the timetable. This is yet another reason for communicating the function and value of art in education.

## Resources

The resources of a large secondary school art department will have to accommodate the main areas of skills selected as appropriate for the chosen educational strategy. At the same time limited facilities must be provided for some pupils to extend their range of experience into more specific activities. In the past this has been where the bulk of capital expenditure has been used. Art teachers are understandably reluctant to buy filing cabinets when the provision for relief printing is inadequate. Nevertheless although adequate money must be provided to service the department as a workshop, there are strong arguments for other equipment which will improve the efficiency of organization. Filing cabinets, index systems, instruction sheets, photocopying and duplicating, folio storage racks and photoslide making facilities are needed in an art department responsible for teaching about a thousand pupils a week with only four to five staff and possibly a technician. Apart from the routine work of the art department, staff are asked to involve themselves in other school activities. This volume of work can only be contained if there are the services, organization and resources necessary.

A large art department requires duplicating, typing, photography and sound equipment, together with a technician capable of operating and maintaining them. Even if there is a central resource bank within the school, and technicians available, to deal with some of these tasks the art department should have the services of its own full-time technician and resources permanently located within the department. The technician should not only perform a servicing function; he should also be expected to help the teachers in their lessons on matters related to technical processes.

# Conclusion

The intention has not been to try to solve all the problems found in secondary art departments. Many operate effectively on the basis of intuition. This book is an attempt to rationalize what most of us know intuitively, in order to encourage other art teachers and head teachers to rationalize their own positions. The objective has been to indicate one way of approaching the problem and encourage others to find their own way through the complex maze of children, materials, stock books, schemes of work, and dinner registers without losing sight of our main reason for being in schools and working with children.

# Appendices

## 1 A progress evaluation sheet

NOTES TO GO ON THE BACK OF PROGRESS EVALUATION SHEET

The numbers correspond to the various sections of the sheet:

1 If you did not join the school in the first year, enter the date *and* the year group.

2 Enter your full name, underline the name that you usually use.

3 Sheet number. Enter the next consecutive number as you add a new sheet.

4 Apart from holidays, these dates should follow on.

5 Give a short description of your original starting point. What started you thinking and working? If your work started from an idea, thought or feeling, enter idea and give a short note on what the idea was. If your work started through the use of materials or techniques, enter techniques and say what you started using.

If you started by using colours, shapes, lines, designs, patterns, textures, enter form and say how you were using them.

6 Description of Activity. Just write a short note on what you did.

7 Interest

How much were you interested in what you were doing?
If you were very interested enter A.
If you were fairly interested enter B.
If you had an average interest enter C.
If you were not very interested enter D.
If you were not interested at all enter E.

This judgement of how interested you were should be your own opinion and not judged against what others think.

8 Success *In your opinion*, was the period of work which you have just completed successful?

> If you thought it was excellent enter A.
> If you thought it was successful enter B.
> If you thought it was average enter C.
> If you thought it was not very successful enter D.
> If you thought it was unsuccessful enter E.

9 Enter here any notes or comments that you would like to make about your work.

10 Take the sheet, with all your comments complete, to an art teacher of your own choice, and discuss what you have done. If the art teacher wants to make any comments they will be entered in this column. Otherwise the teacher will initial your comments.

When you have finished, please replace the sheet in your file.

| Progress Evaluation Sheet | | | | | | | | | |
|---|---|---|---|---|---|---|---|---|---|
| Date of entry[1] | Surname | Christian names[2] | Tutor groups in years | | | | | | Sheet no[3] |
| | | | 1 | 2 | 3 | 4 | 5 | L6 | U6 | |
| | | | | | | | | | |

| Dates of work period[4] | Starting point[5] | Description of the activity[6] | Interest[7] | Success[8] | Pupil's comments | Teacher's comments |
|---|---|---|---|---|---|---|
| | | | | | | |

## 2 An example of timetable blocking

| | | | | | | | | | Time allocation | Art on core curriculum | Art on option |
|---|---|---|---|---|---|---|---|---|---|---|---|
| | Pupil groups of 30 each | | | | | | | | | Total no. of 45 min classroom periods | Total no. of classroom periods |
| | 1 | 2 | 3 | 4 | 5 | 6 | 7 | 8 | | | |
| First year | | 120 pupils in 4 art rooms with 4–5 teachers. | | | | 120 pupils in 4 art rooms with 4–5 teachers. | | | 90 mins | 16 | 16 |
| Second year | | ditto | | | | ditto | | | 90 mins | 16 | 16 |
| Third year | | 90 pupils in 4 art rooms with 4–5 teachers. | | | | 60 pupils in 3 art rooms with 3–4 teachers. | | | 90 mins | 22 | 22 |
| Fourth year | | 60 pupils across 3–4 art rooms but assuming that some 6th form work is taking place at the same time and share the accommodation. | | | | | | | 135 mins to 180 mins | 24 approx. | 36 |
| Fifth year | | | | | | | | | | 24 approx. | 36 |
| Sixth form | | Some blocked timetabling with 4th and 5th year. | | | | | | | 180+ mins | 24 approx. | 24 approx. |
| | | | | | | | | | | 126 C/R periods | 150 C/R periods |

Four art spaces will provide 140 C/R periods on the basis of a 7 period day. With art on the core timetable, this appears to create a deficit of 10 C/R periods but I assume that there could be some sharing in the 4th, 5th, and 6th years.

In an option system the accommodation would be adequate to contain the groups in the manner indicated by shortening the number of groups to be taught in the 4th and 5th year.

All of these proposals fit the average allocation of time and space in secondary schools.

### 3 Support for the six art rationales

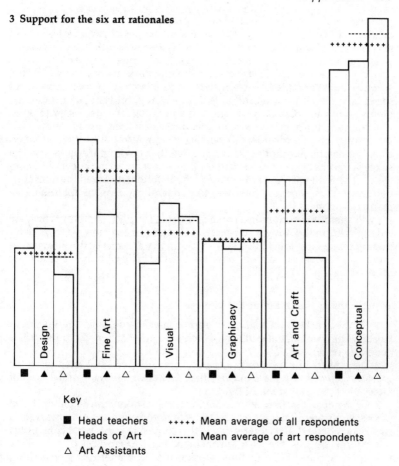

Key

■ Head teachers     +++++ Mean average of all respondents
▲ Heads of Art     ------- Mean average of art respondents
△ Art Assistants

**Fig. A.2**

### 4 Art integrated? The place of art in the curriculum

*Meira Stockl*

I recently carried out an enquiry (a) to discover ways in which art is being *structured* into the curriculum, and (b) to assess the main *aims and attitudes* of a wide sample of secondary school art teachers, head teachers and art advisers towards the major educational change of integration, which is currently occurring in many schools.

The ultimate purpose of the investigation was to help in the re-assessing of art teacher education in the light of new attitudes, aims, and structures

growing in the schools. This last major phase of the work has not yet been tackled. However, I felt that the results of the initial surveys were both surprising and important and might be of interest to other art teachers.

The enquiry involved visiting many schools, meeting many teachers, reading any relevant literature and conducting three major surveys. For the surveys questionnaires were sent to approximately 7½ per cent of all secondary school head teachers, to 7½ per cent of all heads of art departments and to all art advisers in England and Wales. It is necessary to point out that the information from any one of these sources on its own, while interesting, gives a considerably smaller insight into the existing situation than the combination of all sources. Thus many who participated in the surveys may have seen comparatively little relevance to the questions being asked. I hope that if any of the people who so kindly returned the questionnaires see these articles, they will understand my reasons for asking so many questions.

I will attempt to summarize some of the most important points which are emerging from the not yet completed collations of the three surveys. I am hoping that a later article will look more closely at some of the attempts at integration of specific schools, but here I will be taking a more general view of the situation.

## A preliminary summary of the surveys

1 Of the teachers and advisers approached to complete the questionnaires 53 per cent actually did so (which I am informed by the pundits is a good response).

2 Despite the apparent difficulty in organizing successful integration the great majority of responses indicate that they are in favour of some form of integration, at least some of the time.

3 Of the head teachers who replied to the questionnaire, 83 per cent said their schools were attempting (or had attempted) some sort of integration which included art. (It is interesting in this context to know what constitutes integration, as this seems a surprisingly high proportion of schools. I wonder if, in the main, only those schools who *were* attempting something bothered to reply?)

4 From the replies of art advisers, head teachers and art teachers, there is a certain wariness of *organized* integration. The point is made many times that any integration that occurs is dependent upon staff attitudes and their willingness to co-operate for its success. Many say the motivation for integration should come from the teachers themselves. This view is reinforced by the head teachers' response to a question asking what they considered the most necessary conditions for integrated work. The most commonly supported condition was:

To have staff who want to participate in integrated work.

5 Of the heads of art departments who replied to the questionnaire only seven were totally opposed to the idea of art being integrated with other subjects at least some of the time. However quite a number voiced reserva-

tions, as for example this teacher who said: 'I believe that every subject area – be it Art or Technical Studies or Music – has its own intrinsic qualities which are important and should be retained. However, there are large areas of subjects which overlap and much more work can be done to explore these areas without destroying the valuable and individual nature of a particular subject.'

**6** When the heads of art departments were asked which forms of integration they most favoured

33 put – *Expressive Arts departments* (i.e. the 'Arts' subjects together – music, art, drama, poetry, movement, etc.).

30 put – *Design departments* (i.e. the 'Practical' subjects together – woodwork, metalwork, art, home economics, technical subjects, etc.).

58 put – *Creative Design or Creative Arts* (i.e. a combination of the subjects covered by *both* Design and Arts departments.

37 put – *Project-based work in an open curriculum* (i.e. all subjects feeding in where necessary for the work in hand.

35 suggested links with other specific subjects (e.g. art/mathematics, or art/history, or art/environmental studies, etc.).

Many felt that one direction for integration should not exclude the possibility of other links occurring.

**7** In view of that response of the art teachers, this next result is most significant:

Those head teachers who had got interdisciplinary work, which included art, happening in their schools were asked to indicate what form it was taking:

26 said in Expressive Arts departments

54 said in Design departments

36 said in Creative Design/Arts departments

 9 said in an Open curriculum – or Project-based work

20 said in other forms of integration (e.g. 'We integrate when necessary' or 'playing it by ear' or 'with environmental studies', etc.).

*By comparing the above two results it is clearly indicated that the greatest provision for art in the integrated curriculum is being offered in the form of Design Departments (which in most cases means the practical workshop subjects plus art and home economics), whereas the most favoured form of integration desired by the heads of art departments includes both practical and expressive aspects of the subject – that is Creative Design Arts departments.*

**8** Also interesting in this matter of choice of direction of integration is the information which came back from the art advisers. The number of integrated departments operating in the schools in the care of the advisers who replied corroborated that by far the most common form of integrating art at the moment is in Design departments.

Altogether in the schools covered by the survey for art advisers, the following departments are in existence:

104 Expressive Arts departments.

240 Design departments.

153 Creative Design/Arts departments.
 39 Open curriculum/Project based work.
 31 Other forms of integration.
703 No form of integration.

**9** Five of the art advisers were encouraging the setting up of Design departments in their area – and one of those was primarily employed as a crafts adviser. All the others were encouraging the setting up of other types of integrated departments in addition to Design departments. Many of the art advisers emphasized that they felt the direction of integration should be dependent upon the interests of the staff of the particular school. Several art advisers voiced concern over the strong emphasis on design education, for example one said:

Design is only a limited subsection of all that is implied by Art education.

Another adviser said:

. . . many things special to art education and many attempts at integration so far, noticeably design education, have weakened the intrinsic contribution that art makes to the development of children, etc. However, other communications subjects such as drama, English and to some extent, music, in my opinion, offer a very real opportunity for worthwhile co-operation. Much of my work in . . . has tended to stress this angle rather than the design education angle, which tends to assume that because groups of people use many common materials, and pieces of equipment, they therefore must be very closely related educationally.

**10** Many education authorities said they had no art adviser. Several of these authorities intimated that the county or town plans for new schools in their area were being designed to include Design departments. One large county said:

Under secondary school re-organization in . . . integrated design departments are being formed in all schools.

It would seem that to many non-art specialist educationists (e.g. head teachers and education authorities) design departments appear to be the 'natural' direction for the integration of art. Also, that while many art teachers and advisers think this direction is a good one for integration, there are even more who believe that the integration of art into the curriculum should be conceived on a wider plane, to include the arts and other subjects on the curriculum.

**11** The heads of art departments were asked to rate twenty-four suggestions for important functions or purposes of art in the curriculum. The suggestions which received the most universal support were:

(a) To develop more sensitive visual perception.
(b) To encourage growth of imaginative ideas.
(c) To provide opportunity for individual or personal expression.

Not a single teacher participating in the survey disagreed with these three

objectives. It was interesting that the suggestion that the pupils should be given: 'A background understanding of cultural forms (art, architecture, etc.) was seen as an important, but *secondary* objective for art education, by a large proportion of the art teachers.

The two suggestions which received the *least* support were:

(a) To provide a service for the school (e.g. graphics, model-making, etc.
(b) To develop an understanding of technological processes.

To see the complete set of responses of the heads of art departments to these questions see the specimen questionnaire.

It may be helpful to bear in mind the objectives considered to be of most importance by the majority of art teachers, when considering more closely some of the forms of integrated activity which are currently emerging in the schools, which I hope to be discussing in the next article.

I have only been able, so far, to mention a few of the more immediately apparent aspects from the mountain of information I have collected. The rest will probably take some time to get into any sort of order, as my year of secondment is over, and the combining of research with a full-time job is no easy matter. However, I hope this material has provided food for thought.

**Some other objectives for art suggested by the art teachers under question 4**

To promote cognitive understanding (using Piagetian model).

To develop the self-discipline of patience.

Generally to learn how to enjoy art.

To allow for group activities with an allowance for amicable 'working together'.

To assist in some facet of future employment.

To cultivate 'Pride of achievement'. To educate in the appreciation of good workmanship and a job well done.

To give individual pleasure and satisfaction.

Discover and develop any abilities, however limited.

To develop the 'spiritual and psychic' spheres.

To develop an awareness of the relationship between art and other creative arts/art and technology/art/scenics, etc.

To give them the type of environment that they do not normally have in other school departments.

To make good critical citizens.

Chance for each individual to communicate.

**Example of one of the questionnaires**

*Survey B: Heads of Art Departments*

Question 4   Which of the following do you see as being important functions or purposes of art in the curriculum? Please rate each suggestion.

|  |  | Agree strongly | Agree | Not sure | Disagree | Disagree strongly |
|---|---|---|---|---|---|---|
| a | To provide certain *craft skills* (e.g. painting, print making, ceramics, etc.) | 40 | 88 | 6 | 7 | — |
| b | To provide a *service* in graphics or model making etc. for the rest of the school | 3 | 34 | 20 | 55 | 29 |
| c | As a *problem-solving* activity encouraging inventiveness and creative work | 71 | 61 | 4 | 2 | 3 |
| d | To educate towards being *discriminating* about design (design awareness) | 72 | 55 | 12 | 2 |  |
| e | To develop an understanding of *technological* processes | 12 | 61 | 28 | 38 | 2 |
| f | To give opportunity for exploration and understanding of *materials* | 84 | 50 | 6 | 1 | — |
| g | To teach *principles of form and structure* | 50 | 73 | 11 | 6 | 1 |
| h | To give a background understanding of *cultural* forms (art, architecture, etc.) | 30 | 92 | 16 | 2 | 1 |
| i | To give the pupils an opportunity of *making* something | 44 | 68 | 12 | 17 | — |
| j | To discipline the *co-ordination* of hand, eye and intellect | 50 | 74 | 10 | 6 | — |
| k | To develop more sensitive *visual perception* | 101 | 37 | 2 | — | — |
| l | To develop more *objective awareness* | 71 | 64 | 3 | 3 | — |
| m | To develop subjective responses to extend self-awareness | 71 | 56 | 16 | 3 | — |
| n | To provide opportunity for *individual* or *personal expression* | 95 | 42 | 3 | — |  |
| o | To encourage growth of *imaginative* ideas | 97 | 42 | 2 | — | — |
| p | To extend *understanding* of own and other people's *feelings and ideas* | 84 | 44 | 11 | 1 | — |
| q | To encourage an *enquiring* mind | 90 | 45 | 4 | 1 | — |
| r | To provide *leisure* time opportunities for the future | 34 | 76 | 19 | 9 | 3 |
| s | To build up the *self-confidence* of pupils | 59 | 65 | 10 | 7 | — |
| t | To provide an *outlet* for feelings or emotions | 40 | 69 | 19 | 13 | — |
| u | To educate the *aesthetic responses* of pupils | 47 | 76 | 10 | 7 | 1 |
| v | To educate in the possibility of *visual communication* | 52 | 71 | 14 | 2 | 1 |
| w | To provide opportunity for growth of *social awareness* | 32 | 79 | 19 | 10 | 1 |
| x | To provide opportunity for the individual to work from his own | 85 | 54 | — | 1 | — |

# Glossary

It is intended that this glossary should indicate in as simple and precise a way as possible the meaning of certain words or phrases which are found within this course design. There usually is considerable elaboration in the text but the following definitions may form the core of any discussion.

*Affective Objectives* emphasize feeling, emotion, the degree of acceptance or reflection, values, preferences, and commitments.

*Aim* is a statement of the general outcomes one wishes to achieve. Whether implicit or explicit they are derived from value judgements about individuals, knowledge, society, etc.

*Assessment* is a more limited form of evaluation suggesting measurement against a norm which contains limited value judgement.

*Cognitive Objectives* involve intellectual tasks, including remembering, determination of essential problems, recording given material, or combining it with ideas, methods or procedures previously learned.

*Concept* is a general notion, an idea of a class of objects.

*Constraints and Potentialities* are those aspects of the environment, society, or the individual which effect curriculum decisions.

*Content* is information, description of events, processes, techniques or problems, associated with a particular segment of man's knowledge or experience together with the media and materials used in pursuing them.

*Criteria* are the principles for judgement.

*Iconoclast* is one who assails cherished beliefs.

*Evaluation* is the measurement of learning in terms of competence or capacity of the student in achieving objectives or inferred outcomes. Evaluation implies some degree of judgement.

*Method* is the teaching, learning communication strategy, including the patterns of interaction between teacher, pupil and resource.

*Objectives* are directives or directions formulated to achieve the general aim. They are more precise than aims and specify behavioural change that will take place if the objectives are achieved.

*Principle* is a source, root, origin; that which is fundamental; the essential nature; the theoretical basis; a faculty of the mind; a fundamental truth on which others are founded or from which they spring; a law or doctrine from which others are derived.

*Procedure* is mode of conducting activities.

*Process* is sequence of operations or changes undergone.

*Rationale* is reasons and justifications for a particular strategy decision made in order to achieve a particular aim.

*Reflexive* is the interrelationship between the parts, units, or people so that each responds to change in the others. It is the process of interdependence in change.

*Sensory* of sensation or the senses; experience through the senses. (Bob Witkin (1974) used the word *sensate*.) *Sensuous* could have the same meaning but it has emotive overtones. The eye sees the blue sky and the skin feels the cool breeze. These are sensory experiences. The awareness of these are *sensations*, the consciousness of perceiving or seeming to perceive some state or condition of one's body, its parts, or one's mind, or one's emotions.

*Strategy* is a complete set of interrelated curriculum decisions related to objectives, content, method evaluation and organization.

# Bibliography

Allison, Brian (1974). 'Professional Art Education', *NSAE Journal*
Allison, Brian (1973). 'Sequential Programme in Art Education' in David
    Warren Piper (ed.), *Reading in Art and Design (2) after Hornsey* (London:
    Davis-Poynter)
Balchin, W. G. N. (1972). *Introduction to Conference on Visual Education*, York
Barkan, Manuel (1970). 'Guidelines: Curriculum Development for Aesthe-
    tic Education' *Cemerel* Ed. 048, 274
Barrett, Maurice (1971). 'The Universal Teacher' in *Ideas*, Goldsmiths Cur-
    riculum Laboratory (January)
Baynes, Ken (1976). *About Design* (London: Heinemann Educational)
Beard, Ruth (1972). *An Outline of Piaget's Development of Psychology* (London:
    Routledge & Kegan Paul)
Berger, Peter (1971). 'Identity as a problem in the Sociology of Knowledge'
    in Geoffrey Esland (ed.) *School and Society* (London: Routledge & Kegan
    Paul)
Bernstein, Basil (1973). 'On the Classification and Framing of Educational
    Knowledge' in Robert Brown (ed.) *Knowledge, Education, and Cultural
    Change* (London: Tavistock Publications)
Bloom, Benjamin S., Hastings, Thomas J. and Madans, George F. (1971).
    *Handbook on Formative and Summative Evaluation of Student Learning* (New
    York: McGraw-Hill)
Bloom, Benjamin S. *et al.* (1956). *Taxonomy of Educational Objectives. The
    Classification of Educational Goals. Handbook 1. Cognitive Domain* (New York:
    McKay)
Bono, Edward de (1977). *Lateral Thinking: A Textbook of Creativity* (Harmond-
    sworth, Middlesex: Pelican)
Brazil, Robert (1972). *Lecture on Visual Education at York Conference*
Bruner, Jerome S. (1972). *The Relevance of Education* (London: George Allen
    & Unwin)
Bruner Jerome S. (1968). *Towards a Theory of Instruction* (New York, Norten &
    Co)
Chalmers, F. Graeme (1974). 'A Cultural Foundation for Art Education' in
    *Art Education*, **27**, no. 1

Clement, Robert (1975). 'The Function(s) of Art Education' in *The Function of Art Education* (Art Advisers Association)

Cole, Henry (1972). *Process Education (Educational Technology Publications)*

Department of Education & Science (1971). *Art in Schools: Education Survey 11* (London: HMSO)

Dewey, John (1958). *Art as Experience* (London: Putnam)

Dewey, John (1966). *Democracy and Education* (London: Collier Macmillan)

Efland, Arthur (1970). 'Conceptualising the Curriculum Problem' in *Art Education*, **23**

Ehrenzweig, Anton (1967). *The Hidden Order of Art* (London: Weidenfeld & Nicolson)

Eisner, Elliott (1972). *Educating Artistic Vision* (London: Macmillan)

Eisner, Elliott (1973). 'Do Behavioural Objectives and Accountability have a place in Art Education?' in *Art Education*, **26**, no. 5

Erant, Michael *et al.* (1975). *The Analysis of Curriculum Materials* (Sussex University)

Field, Dick (1973). 'Objectives in Art Education' in *Athene*, **16**, no. 2

Field, Dick (1970). *Changes in Art Education* (London: Routledge & Kegan Paul)

Forman, Bernard (1973). 'Currents and Counter-Currents in Art Education' in *Art Education*, **26**, no. 9

Forrest, Eric (1962). 'What Kind of Art in Secondary Schools' in *The Journal of Curriculum Studies*, **1**, no. 3

Getzel, J. W. and Jackson (1962). *Creativity and Intelligence* (New York: John Wiley)

Goodman, Ernest (1973). 'The Purpose and Future of Education' unpublished paper read at Head teachers' Conference in the West Riding

Goodman, Ernest (1975). 'Some Notes on Curriculum and Syllabus Construction' in *Functions of Art Education* (Association of Art Advisers)

Goodman, Ernest (1972). 'Art and the Whole Curriculum' unpublished paper read to a Teachers' Conference in the London Borough of Redbridge

Gowan, Demos Torrance (1967). *Creativity: Its Educational Implications* (New York: John Wiley)

Green, Peter (1971). 'Problem Solving and Design Education' in *Aspects of Education*, no. 13, pp. 55–62

Green, Peter (1974). 'Teaching about the determinants of Visual Form' in *Education 144*

Green, Peter (1974). *Design Education: Problem Solving and Visual Experience* (London: Batsford)

Green, Peter (1974). 'Design Education and Visual Studies' in *NSAE Journal* (May)

Guilford, Joy Paul (1968). *Intelligence, Creativity and their Educational Implications* (San Diego: Knapp)

Guilford, Joy Paul (1967). *The Nature of Human Intelligence* (New York: McGraw-Hill)

Hirst, Paul (1967). *The Educational Implications of Social and Economic Change*. Working Paper No. 12., Schools Council (HMSO)

Hudson, Liam (1967). *Contrary Imaginations: A Psychological Study of the English Schoolboy* (Harmondsworth, Middlesex: Penguin)

Hudson, Tom (1968). Introduction to Catalogue for Bauhaus Exhibition

Krathwohl, D. R., Bloom, B. S. and Masia, B. B. (1964). *Taxonomy of Educational Objectives: The Classification of Educational Goals. Handbook 2: The Affective Domain* New York: McKay)

Langer, Susanne K. (1965). *Reflections on Art* (New York: Oxford University Press Inc.)

Langer, Susanne K. (1953). *Feeling and Form* (London: Routledge & Kegan Paul)

Lewin, Roger (1974). 'The Brain's Other Half' in *New Scientist*, 6 June

Lindstrom, Miriam (1970). *Children's Art: A Study of Normal Development in Children's Modes of Visualisation* (Los Angeles: University of California Press)

Lowenfeld, Victor and Lambert, Britain (1969). *Creative and Mental Growth*, Fourth Edition (New York, Macmillan)

Lowenfeld, Victor (1965). *The Nature of Creative Activity*, Second Edition (London: Routledge & Kegan Paul)

MacDonald, Stuart (1974). 'Unity or Fragmentation' in *NSAE Journal*, **1**, no. 2

MacGregor, Ronald (1970). 'A Modular Curriculum for Junior High School Art' in *Art Education*, **23**, no. 4

McKellar, Peter (1967). *Imagination and Thinking* (London: Cohen & West)

Modgil, Soham (1974). *Piagetian Research – A Handbook of Recent Studies* (London: NFER)

Newsom Report (1963). *Half our Future* (London: HMSO)

Ornistein, Robert (1972). *The Psychology of Consciousness* (San Francisco: W. H. Freeman)

Parker, Cecil J. and Rubin J. Louis (1966). *Process as Content* (Chicago: Rand McNally)

Peters, R. S. (1967). *The Concept of Education* (London: Routledge & Kegan Paul)

Peters, R. S. (1975). *The Philosophy of Education* (Oxford University Press)

Peters, R. S. (1966). *Ethnics and Education* (London: George Allen & Unwin)

Piaget, Jean (1955). *The Child's Construction of Reality* (London: Routledge & Kegan Paul)

Plowden Report (1967). *Children and their Primary Schools* (London: HMSO)

Pluckrose, Henry (1972). *Art in British Primary Schools* (London: Macmillan)

Poincare, H. (1973). 'Mathematics Creation' in P. V. Vernon (ed.) *Creativity* (Harmondsworth, Middlesex: Penguin)

Portchmouth, John (1969). *Creative Crafts for Today* (London: Studio Vista)

Read, Herbert (1952). 'Introduction' to *Creative Crafts in Education*, Seonaid Robertson (author) (London: Routledge & Kegan Paul)

Read, Herbert (1944). *Education Through Art* (London: Faber & Faber)

Reid, Louis Arnaud (1969). 'Art and its Meaning', in *British Journal of Aesthetics*, **9**, no. 3

Reid, Louis Arnaud (1969). *Meaning in the Arts* (London: George Allen & Unwin)

Reid, Louis Arnaud (1958). 'Beauty and Significance' in S. Langer (ed.) *Reflections on Art* (New York: Oxford University Press Inc.)

Ross, Malcolm (1975). *Arts and the Adolescent*, Schools Council Working Paper 54 (London: Evans and Methuen)

Sausmarez, Maurice de (1964). *Basic Design: the dynamics of visual form* (London: Studio Vista)

Schildkrout, Mollie, Shenker, I. Ronald and Sonnenblick Massna (1972) *Human Figure Drawings in Adolescence* (Nuremburg: Brunner)

Schools Council (1975). *The Whole Curriculum 13–16* Working Paper 53 (London: Evans and Methuen)

Schools Council (1975). *Arts and the Adolescent* Working Paper 54 (London: Evans and Methuen)

Stenhouse, Laurence (1970/1). 'Some Limitations of the Use of Objectives in Curriculum Research and Planning' in *Paedagogica Europaea*, **6**

Stenhouse, Laurence (1975). *An Introduction to Curriculum Research and Development* (London: Heinemann Educational Books)

Stockl, Meira (1973). 'The Effects of Opposing Philosophical and Psychological Views on the Development of Art Education' in *Athene*

Tyler, Ralph (1971). *Basic Principles of Curriculum and Instruction* (Los Angeles: University of Chicago Press)

Willats, John (1977). 'How Children Learn to Draw Realistic Pictures' in *Quarterly Journal of Experimental Psychology*, no. 29, pp. 367–82

Willats, John (1977). 'How children learn to represent three dimensional drawings in space' in G. Butterworth (ed.) *The Child's Representation of the World* (London: Plenum Press)

Witken, Robert (1974). *The Intelligence of Feeling* (London: Heinemann Educational Books)

# Index